T0127706

Italian Holidays:
Travel Notes

ART,
HISTORY,
PEOPLE,
CHALLENGES

Virginia Paola Lalli

Translated from the Italian by Sarah Pasetto

authorHOUSE®

AuthorHouse™
1663 Liberty Drive
Bloomington, IN 47403
www.authorhouse.com
Phone: 1 (800) 839-8640

Published by AuthorHouse 02/28/2018

ISBN: 978-1-5462-2984-1 (sc)
ISBN: 978-1-5462-2983-4 (hc)
ISBN: 978-1-5462-2982-7 (e)

Library of Congress Control Number: 2018902430

Print information available on the last page.

"These are my jewels".
Cornelia, mother of Tiberius and Caius Graccus, tribunes of the people.

Julius Caesar: "May not wrath but legality prevail".
Sallust. Conspiracy of Catiline.

This book is dedicated to all war victims. Their memory lives on in plaques, tombstones, commemoration ceremonies, and in the names of roads and squares disseminated throughout Italy. We owe them a great deal and their memory is to be honoured. For this reason, I dedicate this book to each and every one of them.

Introduction And Acknowledgments

IN THIS BOOK, I explore the monuments and works of art of some of Italy's major cities, and the stories of great artists, politicians, saints and heroes. A body of cultural heritage that was created for all to enjoy, bearing messages that ring true to this day. A body of cultural heritage that, when discovered, deeply enriches one's soul.

My personal history has granted me the chance and the privilege to visit and learn about these places, and especially to recognize their value. This is why I felt the duty to share, as widely as possible, all that these places have imparted to me. Fate has certainly played its part, drawing to me the right people to achieve this dream. However, this book is also the story of all those who chose to remain in Italy, no matter what.

I was born in Rome. When I was three months old, I was baptized Catholic by my uncle, a priest. During my childhood, I studied at a Catholic school and spent my free time immersed in the public gardens of Villa Borghese and Villa Torlonia. In those years, Rome suffered from the vicious grip of anarchic terrorism.

For my secondary school education, I chose to pursue the Classics stream in a Catholic school instituted by Saint John Bosco – the priest who devoted his life to youth and children at a time in history when they were usually ill-treated – and his mother Margherita: all extremely virtuous models whom I try to bear in mind to this day.

Thanks to my education in the Classics stream, I became acquainted with the great characters of the Roman Empire and of ancient Greek culture,

politics, *ius*, literature, philosophy, tragedies and comedies. Even today, I enjoy reading or watching plays of the comedies of Petronius, Aristophanes and Menandrus; and the Greek tragedies, from Antigone to Oedipus; without forgetting the philosophical works of Plato and Aristotle, and their theories of the State; or admiring the reasoning of the ancient Roman jurists, from Justinian to Paul, Ulpian, Gaius and others, whose statues all adorn the building of the Italian Supreme Court of Cassation.

Among the Italian writers who are explored during our education, I wish to remember Alessandro Manzoni and his "I Promessi Sposi" (The Betrothed). The novel imparts many lessons to us, including that Divine Providence is at work in our lives and even the most perverse souls can be suddenly redeemed.

After all, the ancient world is very much a part of contemporary life in Rome: even our supermarkets may feature the flooring of an ancient Roman home.

Many Christian saints and martyrs lived in Rome. I will explore the places associated with some of them; however, Rome can (paradoxically) be "far" even for those who live there.

My curriculum (classical secondary education, qualification as a lawyer and studies towards a doctorate) are not unusual. However, it is only recently that I have learned to never take anything for granted, realizing the immense wealth of this hard-won cultural knowledge.

After I passed the bar exam, I discovered the serious issue of abortion from a small number of professionals, and lent my skills to the fight against abortion, although the pro-abortion mentality has been spreading through all levels of society since the 1970s.

I therefore wish to thank all of the pro-life activists with whom I've worked, and who, with great generosity and altruism, have prayed, explained, and defended the rights of the most vulnerable with most limited means, especially because they truly practice what they preach. However, a certain allure may sometimes prevail over scientific fact and awe before a new life.

Therefore, I also wish to spare a thought for the six million children who were aborted in Italy alone, children who today would be my age and might be my colleagues or friends. We remember you and know you are with us. I am certain that sooner or later, we will succeed in changing this hostile atmosphere, this attitude in favour of mass elimination, regardless of the peculiar circumstances of each pregnancy.

I also wish to thank my friends from Losting Girls About Italy, with whom I have visited splendid cities, and celebrated how we managed to brilliantly overcome the personal challenges awaiting us upon our return.

Our tour guides were an essential part of our journeys. They enthralled us with ancient anecdotes about the cities we visited, telling us every detail about special and suggestive places.

Special thanks also go to Dr Roberto Baseggio, of the *Il Salotto delle Arti* association, who showed us the wonders of Italy. I was particularly fascinated by the altar of the of *Duomo* in Pistoia, which was built and decorated over three hundred years, "from generation to generation", by sublimely skilled craftsmen.

I would like to thank my dear friends, who taught me that defeat is only a matter of perspective.

I wish to thank the *Movimento Gruppi di Preghiera Figli Spirituali di Giovanni Paolo II*, the Dominican missionary President, Suor Maria Rosa Lo Proto, and the new Ecclesiastical Assistant, Father Antonio Cocolicchio o.p., for their spiritual guidance, the prayer groups and the many pilgrimages which we have gone on together over the years.

My gratitude also goes to my dear friend Giovanni Camera, now a professional photographer, whose work appears on my book covers. Life is a struggle – what matters is that we fight alongside dear friends.

I thank my graphic artist Daniela de Vincentis, who has been managing my website for many years now, for her talent and her sensitivity towards

animals, which she attends to with great dedication. I look forward to meeting you in person one day.

To the animal rights activists whom I have had the chance to meet: curiosity for nature, our needs and respect for it can be reconciled.

To those who noticed that which I could not, and thus made my life better.

Finally, to all those persons of good will who, even today, in their own little ways, make this country great.

At this point, in this U.S. version of the book, I cannot fail to mention other memories of my childhood and adolescence that I hold dear. The 1980s TV series: Family Ties, Mork & Mindy, the Jeffersons, Diff'rent Strokes, Bewitched, Little House on the Prairie, Family Affair, Fame. It is certainly true that in real life, it is sometimes difficult to understand why people behave the way they do, and that it is better to refrain from using one's superpowers, as these may sometimes be counterproductive.

In addition to Disney cartoons, from Dumbo to the Aristocats, today I sometimes feel close to Madame Adelaide Bonfamille, the kindly owner of Duchess and her kittens. Finally, I am a keen fan of cinema and filmography, following films from the 1950s to present days; of my far too many favourites, I will mention "Roman Holiday", which I also discuss in this book.

Finally, as for singers, I wish to recall Whitney Houston. Her songs are an anthem to the joy, vivacity, freshness and vigour of youth, and were the soundtrack to my adolescence. Sometimes we feel that we must go, leaving our lovely memories to those whom we leave behind.

Therefore, it is true that different cultures can meet and enrich one another…

Finally, I believe that favorable technological and geopolitical circumstances have enabled publication of this book.

Florence: The Governatissima

LORENCE IS A fascinating city, not only because of its magnificent works of art, but also because throughout its history, it has experienced all types of government, under leaders who – as we will see – were extremely important figures.

The ancient Roman town of Florentia was founded in 59 BCE, when Julius Caesar (102-44 BCE) allotted plots of land to his veteran soldiers through the enactment of agrarian laws. However, the actual allocation would take place only under Augustus, between 30 BCE and 15 BCE.

The name "Florentia" appears to have been auspicious: it derives from the Latin word "Floralia", the festivities dedicated to Flora – the Roman goddess of springtime and harvest – celebrated between end April and early May. The colony was established according to the standard form of the *castrum* (military camp): a rectangle protected by a brick wall, with circular towers and four main gates. Two large roads divided the settlement, meeting perpendicularly at the centre of the city: the north-south road was called *cardo* (today, Via Roma and Via Calimala); while the *decumanus* (contemporary Via Strozzi, Via degli Speziali and Via del Corso) ran from east to west. At the intersection between the *cardo* and the *decumanus*, the *forum* developed. This was the main square and centre of the life of every Roman city (today, it is the Piazza della Repubblica).

Florentia's economy soon became prosperous and soon drew about 15,000 inhabitants, also thanks to the Via Cassia, the road opened in 123 CE linking Florentia to Rome. During Hadrian's reign (117-138 CE), important public buildings were erected in the southern part of the city:

1

two big baths, one on the current Via delle Terme and another, even more imposing, in Piazza della Signoria; a *fullonica*, or industrial complex for dyeing wool; a theatre (between the contemporary Via de' Gondi and Palazzo Vecchio); and an amphitheatre, whose existence is still visible in the curve of Via Torta, Via de' Bentaccordi and Piazza Peruzzi. The *Arte della Lana*, or Guild of Wool, was one of Florence's seven *arti maggiori* (greater guilds). The *Arte della Lana* was one of the city's most powerful guilds and had the most members – approximately one third of Florence's population. Its headquarters were in Via di Orsanmichele.

Santa Maria Del Fiore: The Masterly Solution To Brunelleschi's Dome

The *Arte della Lana* sponsored the construction of Florence's cathedral, Santa Maria del Fiore. This name alludes to the mystery of the Incarnation, to the Virgin Mary's conception: indeed, the phrase "the flower and beginning of our redemption" refers to the Feast of the Annunciation, which is celebrated on 25 March and was the first day of the ancient Florentine calendar.

In 1296, the construction of the Cathedral was commissioned to the sculptor and architect Arnolfo di Cambio, who also designed the Palazzo della Signoria and the Church of Santa Croce. However, Arnolfo died in 1302. Three years later, Giotto was chosen to lead the site. However, he only succeeded in designing the bell tower, because he too died shortly afterwards, in 1337. Andrea Pisano was then called to the role, which he fulfilled until his death in 1348. Works resumed after 1350 when Francesco Talenti was appointed foreman, and presented a new plan. Lapo Ghini later took his place, but Talenti regained control of the works in 1370, overseeing the completion of most of the structure, including the octagonal drum. At this point, the problem of the dome had to be addressed.

The construction of the dome gave rise to delicate issues. Such a large dome had not been built since the Roman Pantheon, and concerns grew as to its

stability. A public competition was launched, in which Filippo Brunelleschi and Lorenzo Ghiberti participated. Ultimately, Brunelleschi's project was deemed the best. His plan, based on a knowledge of ancient Roman construction techniques, stood out because it did not require a supporting frame but rather a double self-supporting dome, with a cavity wall between each layer. This solved the intractable technical and economic problems of achieving a sufficiently large supporting framework in wood, which all the other competitors had suggested. Brunelleschi, instead, managed to design an original and rational structure, superseding the forms of Gothic architecture to devise solutions that heralded the advent of the Renaissance age.

In 1436, when the church was consecrated by Pope Eugene IV, Brunelleschi presented a wooden model of the dome. Its construction began in 1438, while the temple-shaped lantern was started in 1445 and completed by Verrocchio with a bronze ball and cross in 1461, after Brunelleschi's death in 1446. In 1461, the dome was assembled, a phase that was completed only in 1471[1].

✣ The Convent Of San Marco: The Government Of Fra' Girolamo Savonarola In Lorenzo De' Medici's Florence

Girolamo Savonarola, a Dominican friar born in Ferrara in 1452, started preaching against the corruption of morals and of the clergy around 1482, from the pulpit of the church of the Florentine Convent of San Marco. The friar's followers soon began to grow relentlessly. From 1491, to accommodate the crowd, the larger church of Santa Maria del Fiore had to host Savonarola's thundering sermons. On 9 November 1494, after Emperor Charles VIII's victorious descent into Italy, the Florentines forced the Medici family to leave Florence.

[1] Crispino. *Le chiese di Firenze*. Giunti. 1999, p. 53.

Piero de' Medici was therefore made to suffer the ignominy of exile and see Savonarola, the staunch anti-Medicean, be appointed as the person who would organize the Republic.

Savonarola spared no effort in issuing extremely strict orders against usury, luxury and corruption. With his impassioned rhetoric, he captivated the Florentines, the objects of his wrath being the Medici family, the oligarchs and the Church itself: evil resided in the corruption of morals, in uninhibited luxury, in the ruthless accumulation of wealth. In Piazza della Signoria, "bonfires of the vanities" were held to burn luxury goods, profane books and works of art. A theocratic government was formed in which the elective body was the *Maggior Consiglio* (Greater Council), gathering 1,500 people.

However, the friar's rigour soon turned out to be inconvenient for everyone. Pope Alexander VI excommunicated him for heresy. However, this did not stop his scorching rhetoric. In 1498, the Medici family returned to Florence and immediately got rid of the friar in a highly exemplary way: he was first hanged and then burned at the stake in Piazza della Signoria.

Savonarola's Treatise on Good Government is thought to have been written between end 1497 and early 1498. Its subject was the defence of the new republican regime that had been introduced in Florence after the fall of the Medicis.

The work compares the damage done by the Medici's tyranny and the new "civil regime", which was embodied by the Florentine people and in Savonarola's view was ingrained in the city's very DNA. For the Dominican friar, political stability and civil balance were the main foundations of an ideal project according to which Florence would become a sort of new Jerusalem, from which a sweeping Christian reform could stream forth.

The Convent of San Marco played a crucial role in Medicean Florence and in Savonarola's Republic at the end of the 1400s. The complex first belonged to the Silvestrine monastic order, which converted it into their headquarters in 1300. In 1435, it passed to the Dominican order. Cosimo de' Medici the Elder commissioned Michelozzo with its renovation, under

whom the complex was expanded between 1437 and 1452. Today, the Convent can be visited and hosts a great body of work by Beato Angelico. In the *Ospizio dei Pellegrini* (Pilgrims' Hospice), visitors may view the Deposition (1425-1432) and the Final Judgment (1431). The friars' cells may be found on the first floor; their marvelous decorations truly justify Beato Angelico's definition as painter "at the service of God". Across the staircase, you may see the Annunciation (1442), which represents a moment of great reflection and contemplation for the artist.

Beato Angelico was born Guido di Piero and, when he became a Dominican friar, took the name of Friar Giovanni. He was later called "Beato Angelico" because of the delicateness and religious fervor transpiring from his work. A humble and modest man, he never returned upon his work because he believed that it was inspired by divine will. Of Beato Angelico's figures, Vasari wrote that they were "so beautiful that they truly seemed to belong to Paradise" – a definition that earned him the moniker of Beato Angelico, expressing his extraordinary evocative skills. Beato Angelico is the patron saint of artists.

At the end of the second corridor are Savonarola's three cells. Here, visitors may see a portrait of the friar, painted by Friar Bartolomeo, a painting of his burning at the stake made by a Florentine artist in the late 1400s, and illuminated manuscripts of the 13th century.

From the corridor, you may access "Cosimo's quarters", two cells that Cosimo de' Medici the Elder had asked to be set aside for his personal use, prayer and meditation. It may be interesting to learn that Cosimo de' Medici had financed the renovation of the Convent in return for a papal bull absolving him of all his sins. A few years after Cosimo's death, a small confidential accounting booklet was found, in which he had made careful notes of the Medicis' donations to art and charity between 1434 and 1471: in terms of 1992 purchasing power, they amount to about 300-400 million US dollars. And the records only started when Cosimo was forty-four years old. How could Heaven be denied to such a generous supporter![2]

[2] Colli Franzone Bonzanini. *Economia Aziendale Online*. Vol. 6. 3/2015, p. 131.

Of course, the family's immense wealth must be considered: in the space of ten years, Cosimo de' Medici bought no less than twenty-seven banks and reunited the same number of Medicean family units. In effect, he governed the city without ever holding a single public post: he believed that wealth was the benchmark against which to measure ethics and culture, and through which he sponsored the work of artists and intellectuals to enhance the Medici family's popularity, the pride of Florence. Cosimo de' Medici managed to de facto affirm the *Signoria* (lordship) model of government even within an established republican framework.

Finally, the gardens of San Marco were home to the famous collection of statues and antiquities of Lorenzo il Magnifico (the Magnificent), which had such great influence on the young Michelangelo.

Savonarola's Treatise contains some notions on the essential features of good government. First, fear of God, because it is certain that every kingdom and every government flows from God, as all things flow from God, He being the first cause that governs all things. The government of the natural world is perfect and stable because natural things are His subjects. Therefore, if citizens fear God and submit to his commandments, this would no doubt contribute to the perfection of the government and would enlighten them in every way.

Second, it is necessary to commit to the common good of the city, and for magistrates and other personages to leave all their property and benefits to relatives and friends, such that they have only the common good in mind. The ancient Romans could dramatically expand their empire because they sought the common good of their cities; God thus rewarded them with temporal goods commensurate with their work, spreading their empire to encompass the whole world.

Third, citizens must love one another, leaving behind all anger and offences of the past, because hatred and envy blind the intellect from the truth. Therefore, councilors who have not been cleansed of such ill feelings often make mistakes. God will punish them for their sins, but will then enlighten them once they have been liberated of such emotions. And when

6

they love one another, God will reward this affection by granting them a perfect government. Because the Romans loved one another and lived in harmony, they experienced good and natural (albeit not supernatural) charity, and God rewarded them. Therefore, if the citizens of Florence would also love one another with natural and supernatural charity, God would multiply their spiritual and temporal goods.

Fourth: justice must be done, because justice purges cities from evil people. This ensures that good and fair men will prevail.

"If, then Florentine citizens would consider diligently and with justice the reason that no other form of government is suited to them than this we have spoken of [i.e., civil government], and if they would believe with faith that it has been given to them by God, and if they put into practice the four things listed above, there is no doubt that in a brief time such a government would be perfected [...]."

"Given, then, that the present government derives more from God than from man, those citizens who, motivated by great zeal for the honor of God and for the common good to observe the things mentioned above, will strive as much as they are able to restore it to perfection, will acquire earthly, spiritual, and eternal happiness."[34]

In Piazza della Signoria, across the fountain sculpted by Bartolomeo Ammannati, among the cobblestones a bronze disk is nestled to indicate the exact spot of the execution, on 23 May 1498, of Friar Girolamo Savonarola, the implacable denouncer of morals and great political enemy of Lorenzo il Magnifico.

To the extent that, it was rumoured, when Lorenzo il Magnifico called Girolamo Savonarola to his deathbed for his final confession, the friar refused to absolve him of his sins. The friar told him that if he should

[3] Savonarola. Treatise on the Government of Florence. In *Selected Writings of Girolamo Savonarola: Religion and Politics, 1490-1498*, A. Borelli and M. Pastore Passaro (transls, eds). Yale University Press: New Haven, CT, USA, pp. 256-257.

[4] *Ibidem*, p. 257.

live, he set Florence free. When Lorenzo refused, Savonarola left without granting him absolution and Lorenzo died without receiving the last rites. Agnolo Poliziano, the poet, philosopher and humanist, witnessed the death of Lorenzo, and tells us more about how this final encounter in a missive today contained in Book IV of his Letters. The story introduces us to one of the most beautiful monuments left by the Medicis, in which they exhibit all their power, wealth, love for the arts and great faith: the Medici Chapels.

"Thus, on the final day before he paid nature its inevitable due, as he lay sick in bed in his villa at Careggi, a complete collapse came so instantaneously that he no longer offered any residual hope of recovery. When the man, scrupulous as ever, realized this, his first priority was to summon a doctor of the soul so that he could, by the Christian sacrament, make confession regarding the wrongdoings he had accumulated over the course of a lifetime. I later had occasion to hear this person relate, full of wonder, that nothing had ever appeared to him greater or more incredible than the way in which Lorenzo, steadfast, ready for death, and unafraid, had recalled past events, had set present affairs in order, and likewise had taken extremely wise and conscientious precautions regarding the future.

"In the middle of the ensuing night, as he rested and reflected, a priest was announced to have arrived with the sacrament, and thereupon roused, he said, 'Far be it from me to suffer that my dear Jesus, who made me, who redeemed me, should come all the way to this bedroom. Lift me out of here, I beg you, lift me out of here at once, so that I may go to greet the Lord.' Even as he spoke, he raised himself as much as he could by himself and supported the fragility of his body on his spirit, and then he proceeded, surrounded by the hands of his friends, all the way to the hall to meet his elder. [...] "When he, weeping, as was everyone present, had said these and other things, the priest finally gave instructions to lift him up and carry him back to his own bed, so that the sacrament could be administered with greater ease. Although he insisted for a while that he would not do this, nevertheless, in order to avoid being less deferential to his elder, he allowed himself to be won over and, having repeated words roughly to the

8

same effect, full now of sanctity, and made venerable by a kind of divine grandeur, he received the Lord's body and blood.

"Then, having undertaken to console his son Piero (for his other sons were away), he admonished him to bear the power of the inevitable with equanimity; that protection from on high would not be lacking, something which not even he himself had ever lacked amid sweeping vicissitudes of politics and finance; that he should simply cultivate virtue and a sound mind; that well-laid plans would yield good results. [...]

"Pico [della Mirandola] had barely left when Girolamo of Ferrara [Savonarola], a man eminent both in learning and in sanctity, and a superb preacher of heavenly doctrine, entered the bedroom. He exhorted him to keep the faith (Lorenzo, however, said that he held it unshaken), to be determined to live as blamelessly as possible from now on (he resolutely replied that this was of course what he would do), to endure death, if this in the end should prove necessary, with equanimity. "Nothing, in fact, would be more pleaseant," he replied, "should this be in God's plan." The man was already making his exit when Lorenzo said, "Father! A benediction, before you leave us." And having simultaneously bent his head and molded his face into every feature of religious piety, he gave a chain of responses, correct and from memory, to the preacher's words and prayers, not even minimally disturbed by the grieving of his intimates, which was now open and beyond disguising itself. You might have said that death had been imposed on everyone else, Lorenzo being the only exception, give, that is to say, the way in which he alone of everyone gave no evidence of pain, of anxiety, of sorrow and preserved his customary mental steadiness, self-possession, balance, dignity, all the way to his very last breath.

"This was a man born for every excellence, the sort who, by shifting his sails, regulated the winds of fortune – at his back, in his face, over and over – to such a degree that you would not know whether he presented himself more determined in favorable conditions or calmer and more self-controlled in adverse ones. His talent was so great, so natural, so penetrating, that where others think excellence in a single field a great accomplishment, he rose to the top in all, equally. Indeed, no one, I think,

is unaware that integrity, justice, loyalty singled out for themselves the heart and mind of Lorenzo de' Medici, like some very charming apartment and shrine. The measure of his graciousness, kindness, courtesy is made plain by the good will toward him on the part of the combined populace and of each and every civic rank. But indeed, amidst all these things, his generosity and magnificence nevertheless outshone the rest, raising him nearly even to divine status by a kind of immortale glory, even as, all the while, he himself pursued nothing solely for the sake of fame and renown but, rather, all out of love of virtue. How great was the devotion with which he embraced literary men! How abundant was the honor, how abundant the deference he exhibited to everyone! How much, finally, of his own effort and attention did he place in searching the world over for books in both languages, and buying them up! How lavish were the expenditures he made in this pursuit, so that not only this generation, or this age, but posterity itself has endured a tremendous loss in the passing of this man!"[5]

The great complex of the Medici Chapels, which host the tombs of the Medici family, is located behind the Church of San Lorenzo. The Chapel of the Princes is in the Baroque style. Crowning the large-windowed chamber, is a dome covered in terracotta, modelled upon the dome of the Duomo of Florence. The Chapel has an octagonal layout, entirely laid over with precious stones and marble in a Baroque design. Under the sixteen coats of arms of Tuscany's Grand Duchies are the six arches of the Grand Dukes Cosimo III, Francesco I, Cosimo I, Ferdinando I, Cosimo II and Ferdinando II. A corridor leads from the Chapel of the Princes to the new sacristy. This room, built by Michelangelo in 1520, reverses the composed equilibrium of Brunelleschi's design in a dynamic, tight ornament on its wall. Under the dome's paneled ceilings, the square room is divided by niches, pillars and lesenes. Michelangelo designed the coffin of Lorenzo il Magnifico and of Giuliano de' Medici, which are watched over by statues of Saint Damian (by Raffaello di Montelupo), Michelangelo's Madonna with Child, and Saint Cosmas (by Giovanni Montorsoli).

[5] Angelo Poliziano. *Letters. Volume I, Books I-IV.* S. Butler (transl., ed.). The I Tatti Renaissance Library, Harvard University Press: Cambridge, MA, USA. 2006.

✠ Dante's Life In Florence: His Meeting With Beatrice

In Piazza delle Pallottole, the opening off Via dello Studio, to the right of the Duomo's apse, a large stone may be seen in the sidewalk next to the entrance to a building. A plaque commemorates what is (supposed to be?): "the real Stone of Dante". Today, in the Piazza, between two shops, you may still see a marble plaque on which the words "*Sasso di Dante*", or "Stone of Dante", are inscribed. History (or legend?) has it that on that site, which used to be a field, Dante would sit on a stone to rest, meditate, and watch the progress on the Cathedral's construction works. The Stone is also connected to an anecdote regarding the great poet and his legendary memory. One day, as he sat on the Stone deep in thought, an acquaintance of his walked by. He asked Dante "O Great Dante, what do you most like to eat?" "Eggs," answered Dante. The year after, the same person walked past again. When he saw Dante sitting there, again deep in thought, he asked him "With what?" Dante promptly replied, "With salt!"

The chapel of Santa Margherita was one of the oldest and poorest churches in the centre of Florence. It enjoyed the patronage of the Portinari, Cerchi, Ricci and Giuochi families. However, it became very famous because it witnessed, and indirectly "caused", Dante's famous love for Beatrice.

Every morning, Beatrice Portinari would leave her father's home on the Corso to pray at the chapel of Santa Margherita, together with her mother, Cecilia de Caponsacchi, and her nurse, Monna Tessa.

And Dante Alighieri too, every morning, would hide around the corner at the other end of the road to watch her, so enchanted was he by her grace and beauty as to fall in love with her.

Few people know that at the time, Dante and Beatrice were only about nine years old!

Today, the chapel of Santa Margherita is the site of the tombs of Beatrice and of her nurse Monna Lisa.

The secret path around Palazzo Vecchio is particularly evocative, as it passes by the Old Tower (once a prison, where Girolamo Savonarola and Cosimo de' Medici were detained in the 15th century), and its crenellated walkway attributed to Arnolfo di Cambio.

Genoa: Simply Superb

✠ The Port, Its Trade And Its Challenges

• •

G ENOA AND ITS surroundings are truly fascinating. Once a maritime republic with an important port, it was a melting pot for all sorts of people and a bustling city. Popes, crusaders, and pirates; kings, noblemen and *dogi*; painters and musicians; explorers and sea traders: all weaved their lives in Genoa and left a trace of their passage in the city.

Genoa was first described as "Superb" in 1358 by Francesco Petrarca, who wrote that travelers would "see a regal city, saddled to an alpine hill, superb for its men and its walls, the mere appearance of which denotes it as lady of the seas".

To gain your own impressions of the city, the first thing to do is to observe it from the sea. You will first see its hills, which drop to the sea in straight cliffs, and on the background, the Apennine range and the maritime Alps, cloaked in candid white during the winter months.

Atop Mount Figogna is the sanctuary of Our Lady of the Guard, whose name recalls its ancient function as sighting post for enemy ships. You are also likely to see an airplane landing or departing from Genoa's Christopher Columbus Airport, a strip of land built directly over the sea.

The mountains fall straight towards the centre of Genoa: in the latter half of the 1800s, the expanding city had to alternate residential and working-class neighbourhoods on the many hills surrounding it.

13

You may admire the façades of the Ripa Maris palaces and place yourself in the shoes of Mark Twain, who wrote in 1868 that "[t]he stately city of Genoa rose up out of the sea and flung back the sunlight from her hundred palaces"[6].

Walking around the port is always interesting, even if you are not familiar with maritime economy, goods, containers and cranes. The port of Genoa is one of the biggest ports of the Mediterranean, in terms of trade. There are two ways to visit the port: the easiest is to take a ferry that sails around the port in 45 minutes, without ever docking. During the ride, a guide explains the history and functions of the sights you will see. For those who prefer visiting the port from the land, there are points of entry.

Trying to imagine what a city used to look like in older times is always a fascinating experiment. In Caricamento, under the old port's causeway, there was only the sea – the site's name serves to remind us that that was where the "caricamento", or loading and unloading of goods, used to take place. The ships unloaded their products: spices, precious silks, food and the ever-useful buckwheat.

The goods were then stockpiled and prepared for sale both within Genoa and in northern Italy and Europe. The market was a hodgepodge of people from many different countries, a cacophony of foreign languages, a blend of exotic flavours.

If you take a few steps towards the sea, you will see two important buildings completed in 1992 by the Genoese architect Renzo Piano, to celebrate the 500th anniversary of the discovery of the American continent. These are a fleet of futuristic windmills and a modern interpretation of an ancient sea crane: the *Bigo*, composed of seven long metal arms that emerge from the sea to support the large sheet for celebrations, and a longer eighth arm (70 metres tall!) on which glides the cabin of a panoramic elevator, carrying viewers over the roofs of Genoa and, rotating, affording them a 360-degree view of the port.

[6] Averame. *101 cose da fare a Genova almeno una volta nella vita*. Newton Compton editori. 2014, p. 12.

Overlooking the port are the Aquarium of Genoa, the old cotton warehouses and the Neptune pirate ship constructed for Roman Polanski's movie "Pirates". Neptune is a real ship with three masts, and is 62 metres long and 16 metres wide. It took two years to build and cost almost 10 million US dollars. After filming, Polanski decided to transform the pirate ship into a floating museum. It is the ideal starting point for a trip along the pirate routes, which after all always coincided with the trading routes. In the Galata Museum of the Sea, there are many paintings that portray pirate ship attacks and the Genoese captains' skillful maneuvers to escape them. This is the story of the veritable battle fought for over five hundred years along the entire Ligurian coast and the Mediterranean, a story in which pirates are the main characters. The most famous and fearsome pirate was Dragut, who terrorized the Mediterranean in the first half of the 1500s. King Charles V asked Andrea Doria to help him defeat the pirates. Dragut was taken prisoner and was locked up in the prison of the *Doge*'s Palace of Genoa. Negotiations for his liberation were commenced: in exchange for his freedom, the island of Tabarca was offered, a coral reef where the Genoese would eventually establish a small colony. From this reef, the *Doge* created a room entirely decorated with coral. Unfortunately, the ornaments are now lost.

To avoid the shame of having essentially paid a ransom, Dragut and Doria deftly agreed to spread a tale that Dragut, tied to a row on a Genoese galley, escaped during the night: a legendary story that would enhance his fame. From then on, pirates would stay clear of the Genoa the Superb, which had fortified and improved its defences to become unconquerable. However, the truth was that Genoa did business with the countries of the southern coast of the Mediterranean, providing the wood and other materials required to build the pirate ships; therefore, the Genoese certainly drew benefits from trading with the pirates[7]. The pirates would soon conquer Tripoli, in Libya, and a few years later, also manage to approach La Valletta, in Malta. Dragut was very well aware that it would be impossible to capture, but his companions had already launched the attack and his pride prevented him from simply watching them die. In the siege, however, Dragut was injured by shrapnel from a cannon, and he died only six days later. He was thus

[7] Averame. *Op. cit.* p. 331.

spared the shame of witnessing the tragedy of Lepanto and the vanquishing of the Turkish fleet.

The heart of Genoese life is Via XX Settembre, near the Genova Brignole train station. The road was designed to be explored by foot and, having been built between the end of the 1800s and the early 1900s, hosts a succession of elegant Secession-style buildings. The imposing Monumental Bridge cuts across it, and Via XX Settembre features broad porticos, which cover the pedestrian part of both sides of the road. Wide and paved with elegant mosaics, it is dotted with roads and staircases, among which the stairs leading to the ancient and beautiful Church of Santo Stefano, built in 972 CE and where Christopher Columbus was baptized.

Finally, tourists reach Piazza De Ferrari, where the porticos continue all around the ample paved square, which is surrounded by a number of elegant buildings: from the colorful façades of the *Doge*'s Palace to the semicircular building of the Stock Exchange and the Neo-Classical Carlo Felice Theatre. In the middle of the square stands the fountain designed by Giuseppe Crosa di Vergagni in 1936.

Santa Maria Di Castello And The Ex-Voto Offerings For Protection Against Storms

The Church of Santa Maria di Castello is one of the oldest churches in the city and the first one to be devoted to the Virgin Mary.

Near the hill of Castello, seat of the city's oldest urban settlements, a small square lies under the façade of one of the oldest churches of Genoa, which is not only a church but also a historical museum. Santa Maria di Castello was built in the 12th century by the *Magistri Antelami* of Como, architects and builders who brought the Romanesque style to the city. The church was built on the remains of another church that, according to tradition, had been erected in 658 BCE by the Longobardic king Aripertus. Etruscan and Roman artefacts were found on the site, dating back to the third

century BCE. In 1442, Santa Maria di Castello was taken over by the Dominican order and became a hub for humanists and writers, some of whom are buried in the church and its cloisters. The Dominican convent, with its three cloisters and eaves, is now a prestigious museum of ancient sacred art, and the decorative features of the church and the convent are one of the greatest examples of 1400s Genoese art.

A guided tour of the cloisters hides many surprises, from the beautiful painting of Paradise by Ludovico Brea (1450-1523), which depicts saints of every social standing as people of God, to a slightly hidden altar for those who traded with Muslims, to the *ex voto* room.

The convent also hosts a collection of about 150 votive paintings, of varying iconography and dates (however, most were painted in the 16th century). The paintings provide hints on the social and devotional life surrounding the church. Some of the paintings are devoted to the maritime theme and are linked to miracles obtained through divine intervention[8]. At the time, there were painters who specialized in producing *ex voto* images: those who were involved in sea life and worked in small booths near the ports. Two famous *ex voto* painters were Angelo Arpe di Bonassola and Domenico Gavarrone (who may have originally been from Savona), who worked in Genoa in the mid-1800s. Bonassola and Gavarrone were artists, but also had expert knowledge of ships and sailing, which they painted with extreme precision between storms and Madonnas couched among the clouds. They would paint half-sinking brigs, rocks menacing shipwreck and, in an upper corner of the painting, a miraculous apparition. If the painting's commissioner was from Genoa, they would paint Our Lady of the Guard; if he was from Savona, then Our Lady of Mercy; while for sailors from Chiavari, there was Our Lady of Grace.

[8] Associazione culturale Santa Maria di Castello. *Genova. Santa Maria di Castello.* Sagep Editori 2014, p. 21

✱ The Duomo Of San Lorenzo And The Holy Graal

The original structure was erected in the 9th century and became a cathedral in the 10th century. Between the 11th and the 13th centuries, it was rebuilt in a Romanesque-Gothic style.

In Piazza San Lorenzo, you may take a picture with the two large marble lions on the steps. These date back to 1800s Neo-Classicism and were made by the Genoese sculptor Carlo Rubatto.

In the bigger side chapel, you may see the precious silver ark holding the relics of Saint John the Baptist, which were brought over from the Holy Land during the Crusades. However, this ark is not the only historically important object in the cathedral. Indeed, the enclosure of the Cathedral of San Lorenzo is home to the Treasure of San Lorenzo, a collection of immensely valuable artistic and religious artefacts. Among its most important pieces is the green Holy Basin, produced in the 1st century CE. The Holy Basin is a green hexagonal plate about 30 cm in diameter and 4 cm deep. It is important because of the high quality of its craftsmanship, being a prime example of the Augustean age, but also because it was allegedly used by Jesus Christ during the Last Supper to celebrate Easter and thus establish the sacrament of the Eucharist. In the 1700s, the historian Ratti firmly expressed the belief that that was the plate used by Jesus for His Easter meal, and that it had collected the blood of the Saviour. It is thus considered a "Holy Grail", as confirmed in more recent times by Andrew Sinclair. To quote from Sinclair's book, *The Adventure of the Grail*: *"The real Grail is the Holy Basin of Genoa...Whatever its origins, the Holy Basin was such a venerated object in the Middle Ages that it had to be placed under the guard of twelve knights, on the example of Christ's twelve apostles and of the Twelve Knights of the Round Table"*[9]. The acquisition of such a treasure is owed to Guglielmo Embriaco, who led a memorable battle that is moreover immortalized in a fresco painted by Carlone in the chapel of the *Doge*'s Palace.

[9] Orselli-Roffo. *Genova segreta*. Ligurpress. Genoa, 2010, p. 116.

To capture Jerusalem, on 15 July 1099, William the Drunk and Godfrey of Bouillon – as narrated by Torquato Tasso in Jerusalem Delivered – dismantled their very own ships: the skilled Genoese boat-builders used the timber to construct two towers for the siege. At the time, these were futuristic moves, that played a decisive role in the Christians' capturing of the holy city. The enemies' efforts to set the towers on fire with flaming arrows failed, as the wood had been covered in leather to defend from this very possibility.

When Genoa was conquered by Napoleon Bonaparte's French forces, the plate was brought to Paris in 1806. It was returned to Genoa in 1816, but was broken in ten pieces (of which one was missing).

The Cathedral is also home to another important artefact. On 9 February 1941, during World War II, the English-led bombing Operation Grog was carried out over the city and lasted 31 minutes. By the end, 254 buildings were destroyed or seriously damaged, 137 people were killed, and 227 were injured. The Cathedral itself did not sustain much harm: the roof had collapsed, but a bomb that had been dropped inside it failed to detonate. Many citizens of Genoa thanked Saint John the Baptist and Saint Lorenzo for the miracle. If you enter the Cathedral from the main entrance, on the right-hand side, a replica of the explosive is prominently displayed next to a plaque explaining the events of that fateful day in 1941.

During politically difficult times for the Republic of Genoa, the Cathedral was also the setting for two important ceremonies held on 25 March 1637, the day of the Catholic Feast of the Annunciation. In the first, the *Doge* proclaimed the Virgin Mary "Queen and Protector of Genoa". In the second, a new statute of the Madonna was placed inside the Cathedral and given the royal crown, scepter and keys to the city. It was the *Doge* of the time himself, Brignole Sale, who handed these "State" symbols for the Virgin Mary to the Genoese archbishop Giovanni Domenico Spinola, amidst celebratory bells and cannon shots. Cardinal Domenico Spinola then solemnly proclaimed the Virgin Mary Queen of Genoa and proclaimed that the motto "*Et rege nos*" ("rule over us"), taken from the Book of Psalms (29:9) was to be engraved on every entrance door of the

city, on the Republic's banners and on the new golden coins, or *scudi*, that had been made for the occasion. A few years later, the Republic of Genoa commissioned Domenico Fiasella with designing a statue to be placed on the Cathedral's main altar, replacing the wooden one that was sculpted by Giovanni Battista Bissoni and is today kept in the Church of San Michele di Fiorino. In 1652, Bartolomeo Bianco created the statue in bronze and placed it on the city's main altar, which for the occasion was transformed into a throne. The Virgin Mary, seated with baby Jesus in her arms, holds the scepter while angels crowned her. A bird's-eye view of the city is sculpted on the lower edge of her cloak. Jesus appears to be holding out to Mary a parchment inscribed with the words *"Et rege eos"* ("Rule over them") and entrusts to her care the citizens of Genoa, who become her free servants, as they have accepted such subjection out of love. Jesus, in turn, offers His own Mother to all, as a privileged pathway to salvation and eternal life.

Giovanni Francesco Brignole Sale's mandate as *Doge* expired on 11 July 1637 and he died later that same year, although the precise day was not made known. He was buried inside the Church of Santa Maria di Castello. The ex-*Doge* had the doorway to his house adorned with a crowned initial "M" for Mary, a decoration that may still be seen today.

✸ The Lanterna Of 1128: The Symbol Of Genoa

The symbol of Genoa is the Lanterna. Originally, this had two functions: first, as a lighthouse, and second, as a fortification to prevent attacks. The tip of the Promontory had already been home to a small Roman fort overlooking both the sea and the nearby Via Aurelia; the fort continued to be used after the fall of Rome. Indeed, as reported in an 1128 decree of the Consuls, the people living on the outskirts of Genoa used it as a guardhouse. A first tower was erected in the fort in the early 12th century. Although modest in size, it was certainly very important: it served not only the port's signaling purposes, but also to communicate the arrival of suspicious ships through fireworks (by night) or sails and flags (by day).

In 1320, the Lanterna was equipped with 52 oil lamps, which were fueled from the stock of the *Doge's* Palace. On average, one barrel of oil was consumed each month, for a total of about 530 litres per year. The lamps were lit by the tower's watchman, who would climb up the tower and work under the light of tallow candles. The Lanterna's current structure dates back to the mid-1500s, when the old battlements were replaced with balustrades. The Lanterna, standing 127 metres tall, is the city's most important monument, although the glorious lanterns after which it was named have long been replaced with a powerful state-of-the-art light source – or rather, by an intricate system of lens that is capable of greatly magnifying the brightness and strength of the rays of light.

The Lanterna has even witnessed the birth of a child: Giano, the son of King Giacomo of Lusignan, who was imprisoned here with his wife for some years around 1375.

The Lanterna has often been struck by lightning. We know that this happened in 1481, when a lightning bolt killed a watchman, and then in 1602, when part of the upper structure was destroyed. In 1603 it was struck again; on that occasion, a plaque was built into the wall bearing the inscription *"Jesus Christus rex venit in pace et Deus Homo factus est"* ("Jesus Christ the King comes in peace and has become man"). Today, the original plaque can be seen at the base of the upper tower. In 1778, a system of lightning conductors was installed.

Today, the Lanterna is a tourist attraction that may be visited on certain days… as long as you have good legs and lungs, since (fortunately) it has 365 steps and has not yet been fitted with an elevator!

It may be interesting to note that in 1449, Antonio Colombo, Christopher Columbus's paternal uncle, was appointed one of the Lantern's watchmen[10].

The 600 metres of the Lanterna's walking route afford views of parts of the Port that are usually closed to the general public. At the end of the route, you will reach the tall lighthouse, severe in appearance but standing

[10] Orselli-Roffo. *Op. cit.* p. 66.

bright and proud of its history. Indeed, for nine centuries now, those who approach Genoa by sea are welcomed by the lighthouse, which from its 117 metres on sea level, casts strong, yellow rays of light 33 miles out into the distance.

✱ Via Garibaldi: The *Rolli*, A Unesco Heritage Site

The *Strade Nuove* (New Roads) and the system of the *Palazzi dei Rolli* (Rolli Palaces) in Genoa's historical centre consist of a group of Renaissance and Baroque palaces constructed in the late 1500s-early 1600s, when Genoa was at the height of its financial and maritime power. The forty-two *Palazzi dei Rolli*, which were made UNESCO World Heritage sites in 2006, are among the at least 120 palaces that have received such status in this city, which, from the late 1500s to the early 1600s wielded extraordinary economic and political power within Europe.

Political and economic power were closely intertwined. If Genoa aspired to a position of commercial supremacy in the Mediterranean, then it had to be capable of competing with the other European powers, and specifically of attracting and welcoming the noble classes, enchanting them with its works of art displayed in the private homes of the Genoese aristocracy, and leading them – perhaps between a promenade, a play and a sumptuous banquet – to sign important commercial treaties. This was the system established by Andrea Doria, one of the most important characters in Genoese history and who launched that which is rightfully called the city's "golden century".

Andrea Doria was the undisputed – perhaps slightly tyrannical – leader of the city for almost fifty years, although he remained outside the Genoese political scene.

The Doria Pamphilj Palace (today called *Villa del Principe*, or Prince's Villa), received Andrea's particular attention beginning in 1521. The best artists of the time would soon work there: Piola, Titian, Perin del Vaga

(Raphael's apprentice in the Vatican Lodges, who had been out of work since the Sack of Rome in 1528). The building – whose external walls are also entirely frescoed – and its gardens were a true wonder of their time. The gardens were perched atop the very edge of the sea and had a small private port; its other side faced the hills of Genoa.

The grounds were so beautiful as to enchant even Emperor Charles V when he visited in 1535. During the banquet held in his honour, the solid gold plates were thrown to sea after each course. The Emperor was deeply impressed, but could not possibly know that Andrea Doria had a strong net cast at a convenient depth, to catch his tableware!

Andrea's palace did not fall under the system of the *Rolli*, even though he had created it himself to decide who should host foreign sovereigns and delegates. Indeed, Andrea wished to offer his hospitality to emperors and rulers without having to account to anyone. According to the *Rolli* system, the lodgings of illustrious foreign guests were decided by drawing lots. The owner of the structure drawn would be required to host the guest.

Therefore, the *Palazzi dei Rolli* offered an extraordinary variety of lodging solutions, with spectacular salons, courtyards and loggias overlooking gardens, constructed on different levels in relatively limited space. They also provide an original system of private residences conceived to host illustrious visitors. The palaces' owners were thus required to host these visitors, thereby contributing to the circulation of an architectural and cultural model that drew the attention of artists and travelers, who, through their work and writings, fostered its diffusion abroad.

Each *Rollo* was divided into three lots, into which the palaces were classified by grandeur and beauty. The lodgings were assigned by a random draw, depending on the importance of the visitor. The first lot was reserved to cardinals, princes and viceroys; the second lot was for feudal lords and governors; while the third was for lesser princes and ambassadors.

The main palaces on Via Garibaldi are Palazzo Rosso, Palazzo Bianco and Palazzo Doria Tursi.

Palazzo Rosso was the residence of the Brignole-Sale family. It dates back to the 17th century and is decorated with frescoes painted by the greatest artists of 1600s Ligurian art, such as Piola, De Ferrari, Carlone and Tavella. In 1874, the owner at the time, Maria Brignole-Sale De Ferrari, Duchess of Galliera, donated it to the city. However, this was not her only gift to Genoa. Galliera Hospital bears her name because of the conspicuous sums she donated towards its construction. Inside Palazzo Rosso, to this day one may see precious furniture and a rich art gallery, with paintings by Durer, Veronese, Guercino, Grechetto, Strozzi and Van Dyck. The Mirador Belvedere affords tourists a splendid view over the entire city and its historical centre.

Palazzo Bianco was built between 1530 and 1540 for the Grimaldi family. In 1884, Maria Brignole-Sale De Ferrari, Duchess of Galliera, donated it to the City of Genoa, together with a remarkable body of antique and modern artwork "for the creation of a public gallery" which the city did not yet have. The artwork includes a vast range of Genoese paintings from the 1500s and 1600s, from Cambiaso, Strozzi, Piola and Magnasco.

Constructions on Palazzo Doria Tursi began in 1565, commissioned by Niccolò Grimaldi. The palace is the most majestic building on Via Garibaldi, and is the only one with two wide gardens. In 1597, it passed under the ownership of the youngest son of Andrea Doria, Duke of Tursi, after whom it was named. The seat of the municipal government since 1848, from 2004 it has also accommodated the expansion of the Gallery of Palazzo Bianco, to which it is connected through hanging gardens. Palazzo Doria Tursi is home to prized ceramics and tapestries, as well as the famous Guarnieri del Gesù, a violin that once belonged to Niccolò Paganini, the illustrious violinist who was born in Genoa in 1782.

In 181, Paganini played in Turin for King Carlo Felice. Improvising, he performed with such passion and vigor that the tips of his fingers were bleeding. When the King asked him to replay his last piece, he curtly replied "Paganini does not repeat"[11].

[11] Averame. *Op. cit.* p. 152.

But let us now see his *Cannone*, or "Cannon": a violin made by Giuseppe Guarnieri del Gesù, master luthier of Cremona. In 1743, a generous anonymous fan of Paganini gifted him this masterpiece. It was Paganini himself who nicknamed it "Cannon", because of its robust sound but most importantly, because it had survived the wrath of Paganini's woman, Antonia Bianchi, who during a fit of jealousy had thrown it to the ground; however, fortunately, it was saved by Paganini's butler.

Alongside the *Cannone*, one may also see the "Sivori" (created by the luthier J.B. Vuillaume in 1834), a faithful replica of the *Cannone* that Paganini gave to one of his students, Camillo Sivori, and other interesting mementos such as signed letters and notes.

However, there is still a way to hear the *Cannone*'s forceful notes today. Since 1954, the Paganini Award, an extremely demanding competition, has been held in Genoa. Of the three rounds of the competition, two may be attended by the public. The winner of the prize is allowed to play the *Cannone* once[12].

✲ The Church Of The Santissima Annunziata

While the *Rolli* are private buildings where important families may display their history and prestige, churches are the public sites for this lay celebration, where all Genoese citizens, noble and non-noble alike, may enjoy the city's wealth, made up of the fruits of its maritime and commercial trading. One church that cannot be missed is the Church of the Santissima Annunziata, or Most Holy Annunciation. Located in the central Piazza della Nunziata, its majestic 1800s prodrome faces the roundabout that streams traffic towards the sea at the end of Via Balbi, towards the Principe train station. The church, whose construction began in the 1500s, was drastically renovated in the 1600s by will of the Lomellini family. The Gothic-style interiors were covered with polychromic marbles, golden reliefs and colorful frescoes. The church was lengthened, increasing

[12] Averame. *Op. cit.* p. 153.

its stateliness, and its façade was completed. Entering the Church of the Santissima Annunziata is also to enter one of the city's most important art galleries, as here, between the 1500s and the 1800s, the greatest Genoese painters were appointed to fresco its vaults, create oil paintings, and embellish its ceilings, chapels and altars, giving rise to a gallery of sacred art immersed in sculptures and illuminated by bright windows and shimmering gold. The church is a triumph of religious subjects painted by artists of the caliber of Carlone, Fiasella, Assereto, Piola, Ansaldo and De Ferrari, in an enrapturing Baroque setting.

The Castle Of Captain D'albertis, And The Route Of Christopher Columbus

Built in the early 20th century over a rampart of the walls dating back to the 1500s, this castle is a masterpiece in the eclectic mock-Medieval style that was fashionable at the time. It was the home of Captain Enrico D'Albertis (1846-1932), an extraordinary navigator, traveler, explorer, writer, ethnologist, philanthropist and builder of sundials: a fascinating character, whose life is well recounted in the Museo delle Culture del Mondo, or Museum of Cultures of the World, which his castle hosts today.

In 1886, D'Albertis ordered the castle to be built, drawing inspiration from famous Ligurian civilian and military architecture. In 1932, it was turned into the Museo delle Culture del Mondo, originally conceived as a homage to Christopher Columbus, who D'Albertis deeply admired: see the frescoes depicting the caravels leaving Palos for San Salvador, the sundial with Christopher Columbus's bust marking time at San Salvador, the bas-reliefs with the commemorative caravels, the statue of Columbus as a youth standing in the loggia of the Columbian room overlooking the sea. This statue, by the sculptor Giulio Monteverde (1837-1917), portrays Columbus as a young man sitting on a bollard, looking out to Genoa's sea with a daring look in his eyes, as he waits for Fate to tell him when

to depart. The statue literally overlooks the sea from a terrace, making its evocativeness all the more alive.

Every detail of the room is a nod to Christopher Columbus. This was the specific intention of D'Albertis, who in 1893 repeated Columbus's renowned voyage across the Atlantic Ocean with navigating instruments (a quadrant and an astrolabe) that he had ordered skillfully reconstructed for the occasion.

Other than the room dedicated to the Captain and his living quarters, the second itinerary of the Museo delle Culture del Mondo leads visitors around artefacts from South America, Native American lands and Asia.

The Turkish Room is particularly distinctive and represents the taste for the exotic that was diffuse in the late 1800s. The room is a romantic reconstruction of a Middle Eastern nomadic world that attracted much interest from the West at the time; here, you may see objects and furniture from China, India, Japan, Turkey and Persia.

Wandering Around The Caruggi

Genoa's historical centre is a labyrinth in terms of both time and topology, what with its tall houses and narrow alleys. It may strike visitors as absurd, but it is very much possible to lose oneself in the centre: the knowledge that you need only walk downhill to reach the sea and the old Port, or uphill to reach the modern centre, is little consolation.

Tourists do not need much time to enjoy the wonderful *caruggi*, or alleyways, following the scent of *focaccia* (white pizza), the sound of a church's bells, the clinking of glasses of bars preparing the *aperitivo*, the benevolent gaze of a Madonna sculpted on the corner of a building, the sequence of shopwindows… The historical centre is a marvelous melting pot of humanity, where traces of history and daily life combine, unorganized and confused, fascinating and deafening, just like life itself.

Everyone, Genoese and visitors alike, should try at least once to stroll without destination among one of the most fascinating historical centres of Europe... and perhaps of the world?

❦ Historical Shops And Famous Clients

The shop of Pietro Romanengo, near Piazza Campetto, is truly spectacular: its entrance, the architrave of which is adorned with bas-reliefs, opens onto an extraordinary treasure trove of sweets and candies. Indeed, the Romanengo family have been confectioners since 1780. At their shop, you may find candied fruit, almond paste, hand-candied violets, jams, quince paste, syrups...all in a space that has changed very little since the 1800s.

A few steps away, another temple to confectionery may be found: the *Gran Bar Pasticceria* belonging to the Klainguti brothers, who had come to Genoa to travel on to the United States, but then decided to remain in Italy. Of the clients who have visited the patisserie since its opening in 1828, one of the most famous is certainly Giuseppe Verdi; in honour of the first representation of the Falstaff at the city's Teatro Carlo Felice, a special dessert was created and named after the opera. A note signed by the illustrious composer is framed and displayed to this day on a wall of the café: "Dear Klainguti, your Falstaff is better than mine".

The butchery at Via dei Macelli di Soziglia 8 is also fascinating: notice the counter, of finely carved marble. Here, you can see the faces of Mazzini, D'Azeglio, Garibaldi and Bixio, protagonists of Italian independence, and take a walk through history as you do your grocery shopping.

In the neighborhood of Quarto, you can have a meal at the Osteria del Bai, where Garibaldi had lunch with the *Mille*, his thousand-soldier army, before leaving for Marsala. For this expedition, Garibaldi had asked the shipbuilder Raffaele Rubattino to provide him with a ship; Rubattino gave him one that was being disposed of, saying "as far as I'm concerned, it was

stolen, all the best". A statue of the shipbuilder stands at Caricamento, in front of the Port of Genoa, and was made by the sculptor Augusto Rivalta.

☩ The Doge's Palace: The Doge's Political Life

On 23 December 1339, Simone Boccanegra was named *Doge* of Genoa. This inaugurated the age of the "perpetual *Doges*", who were powerful rulers of the city but also prisoners in "their own palace", as written by the French judge J.B. Mercier in 1785.

Boccanegra was elected on popular acclaim, but the election system subsequently designed was to prove even more popular. This system, based on a double draw, went on to inspire the invention of the lottery, because the Genoese would bet on the "numbers" associated with those who were to be elected to the governing position. Therefore, the first lottery, ratified in 1630, was officially held in Genoa.

The ceremony for crowning the *Doge* usually took place on a Saturday. The regalia pertaining to the position would be brought to the apartments of the Doge's Palace, to be consigned to the newly elected ruler during the ceremony. An imposing procession, escorted by halberdiers, would leave the Palace for the Church of San Lorenzo, where the *Doge* would meet the archbishop. The new *Doge* would then be blessed with the "Cross of the Zaccaria", a golden jewel of Byzantine artistry.

The *Doge* would then return to the Palace and enter the Throne Room where, after exchanging greetings with the senators, the swearing-in ceremony would take place before the Dean of senators. Dressed in a velvet cloak, a mink shawl, a cap and a crown, the *Doge* would receive the official sword and the scepter.

The inauguration banquet would take place on the following Sunday. After a solemn Mass and a speech in the Cathedral, the city's most important members of society would gather in the room of the Great Council, where

they would be served exquisite dishes on solid gold plates. In Genoa, such hospitality expenses were borne by the *Doge* and were certainly no trivial affair, if one considers that 314 guests were invited to the banquet celebrating the election of Gian Battista Ajroli. However, food was not the largest expenditure in the *Doge's* budget: "court" parties were frequent and were often an excuse for constructing immensely expensive scenographies, comparable to real theatrical machines, for which great artists such as Perin del Vaga and Piola would also be enlisted. In this way, the *Doge* could display his power and authority, to the aristocracy and ordinary citizens alike.

Still, life was not one big party. As mentioned above, for the two years of his mandate, the *Doge* lived almost as if "under house arrest": he was allowed to leave the Palace only five days a year, usually to attend solemn Mass. All other outings had to be authorized by the Senate. This strictness was to prevent the *Doge* from being distracted in the slightest from his governing duties[13]. In any case, he could attend the Cathedral by means of an overpass and had eight rooms for receiving guests, as well as other rooms for his private use. From the mid-1500s, Swiss halberdiers watched over his safety.

The Palace's history is complex and has always been closely intertwined with that of the city: from residence of the *Doge*, it was later converted to the seat of the government of the Republic and, subsequently, the Palace of Justice.

Today, after careful and thorough renovations, the old Palace (Neoclassical in aspect but whose basic structures date back to the Middle Ages) was turned into a multi-purpose site for exhibitions, concerts and conferences. All this and the sheer beauty of the monumental construction itself make the *Doge's* Palace one of Genoa's main attractions.

In the *Doge's* Palace, the prisons were located in the People's Tower, which is also called the "Grimaldine Tower", from the name of one of its cells. The prisons were linked to the main palace through a passageway on one of the upper floors. Its current layout dates back to the 17th century, although

[13] Dolcino. *I Misteri di Genova*. Nuova editrice genovese. 2014, p. 310.

it was used as a prison since the late 1500s. The Grimaldine Tower and its somber rooms may be visited with guided tours.

To be convicted of a crime, one did not have to commit particularly serious misdeeds; "it sufficed to have sullied the city's roads with rubbish, or simply have vandalized other people's gates with cuckolding symbols or similar allusive signs". Those found guilty of repeatedly uttering blasphemy were punished with the chopping off of their tongue, while those who sold poisoned drinks would have their nose and ears cut off.

Used as prisons for almost 500 years, the cells of the Grimaldine Tower have hosted famous inmates.

The walls of the cells bear testimony to the passage of time, and their graffiti are expressions of the political evolution of the city and of Italy generally. Painted with coats of arms and inscribed with dates going back to the 1600s and 1700s, views of the port, troops and ships, by artists of the Genoese school[14].

Indeed, in the 500 years of the prisons' history, only one successful evasion was ever documented: that of Domenica della Chiesa in 1612, a 17-year-old boy from a noble family who had been arrested and imprisoned without trial after an argument with his brother, who was a Senator of the Republic. Through a series of tricks, the boy managed to climb on the bell tower. Here, using the flagpole as a vaulting pole, he lowered himself onto the terrace under the main courtyard of the *Doge*'s Palace and ran away.

Another famous inmate of the prisons was the pirate Dragut. He was detained in a cell reserved for important detainees, which was spacious and had a large glass window overlooking the Port of Genoa.

[14] Averame. *Op. cit.* P. 69.

✲ The House Of Christopher Columbus And His "Insane" Trip

Christopher Columbus's original house was almost completely destroyed in the French naval bombings of 1864. What we see today is a reconstruction made in the 18th century, a relatively faithful replica of what once was the home of the wooler Domenico, with a storefront on the ground floor and the family rooms on the upper floor[15].

The house located near Porta Soprana thus once belonged to Domenico Colombo, who lived there with his wife Susanna Fontanarossa and their children Cristoforo (Christopher), Diego and Bartolomeo, from 1455 to 1470, before they moved to Savona. Christopher spent his childhood and early youth here, as demonstrated by a contract for rent signed between Domenico and the monks of the nearby monastery, of which today a portico remains. A copy of the contract may be purchased as a souvenir.

In addition to sailing, Christopher Columbus also helped his father in his trade. In other words, his background was not particularly wealthy. Today we enjoy the benefit of hindsight, but in his day, Christopher Columbus was certainly not the only young man who wanted to sail for foreign lands. Similar attempts had already been made and failed; although they had taken place a long time before, in Genoa the echoes of those tragic facts still resounded strongly.

The sea has always been the "working place" of the citizens of the "Superb" city, the site where they conducted trade and commerce. Shipwreck was of course the most common and fearsome risk, when in the space of a few minutes, all could go lost: the goods, the ship, life itself. One of the most famous shipwrecks in Genoese history is that befalling the Vivaldi brothers. The Vivaldis were one of Genoa's oldest noble families and their renown, which transcended the city, is due to their unsuccessful attempt to circumnavigate Africa. In 1291, as written in Jacopo Doria's records, Ugolino Vivaldi, his brother Vadino and Tedisio Doria began a voyage that

[15] Roffo-Donato. *Guida insolita ai misteri, ai segreti, alle leggende e alle curiosità di Genova*. Newton Compton editori. 2015, p. 88.

had never been attempted before. With the utmost care, they prepared two galleys. In addition to the crew, two friars were also taken on board, and they sailed towards the "dark ocean", to reach India by sea instead of by land, over a significant part of Asia.

Once past the Straits of Setta, the two galleys were last seen near Gozora, just above the Equator: after this, there are no more records. The Vivaldi ships almost certainly shipwrecked in the Atlantic along the African coast, but their attempt, which was considered extraordinary for the times, was so renowned and so acclaimed that some scholars believe that Dante took the two Genoese brothers as a model when writing the first chapter of his Divine Comedy, when he narrates Ulysses' "mad flight" beyond the Pillars of Hercules[16].

Columbus's younger brother Bartolomeo moved to Lisbon and became a cartographer. This passion led him to discover old maps and reports written by sailors. Christopher, seeing his father's disastrous economic conditions, left Liguria in 1474 and joined his brother in Portugal. Bartolomeo's enthusiasm and fantastical dreams soon inspired him, and the two brothers would take part in Christopher's fourth trip to America in 1504. Through Bartolomeo, Christopher also befriended a cosmographer, Bartolomeo Parestrello, whose daughter, Felipe Moniz, he would marry in 1470. Parestrello was a captain who colonized the island of Porto Santo, where he had collected maps and ancient Greek and Arabic books on the Atlantic routes of the African coasts, Madeira and the Azores.

Christopher Columbus was certainly aware that his venture was likely to fail. However, also thanks to his courage and his gifts, he managed to overcome obstacles which upon a first glance seemed insuperable, as is clear from some of the voyage's events. For one, a water spout threatened his ships during his fourth trip to the American continent. Still, far from being afraid while the crew feared the worst, he climbed onto the quarterdeck and drew his sword, recited passages from the Gospel, made a cross in the air and then a circle embracing the entire crew: the water spout died down only a short distance away from the ships. Also, Columbus believed that

[16] Orselli, Roffo. *Op. cit.* p. 70.

ball lightning, which usually portended storms, were actually auspicious signs – as he never tired of repeating to his sailors.

It is said that during a banquet held by Pedro González de Mendoza in honour of Columbus, an envious guest said that someone would eventually discover the trade route to the Americas, even if Columbus did not; therefore, his merit was only relative. Columbus took a boiled egg and asked the guests to try to balance it upright on the table. None of the guests succeeded. When the egg made its way back to Columbus, he slammed it down on the table, so that it did stand upright. This was to say that anyone could have done it if they only had the creativity and courage – and they did not.

✦ Palazzo Reale: The Choreographic Façade And The Bridge Overlooking The Sea

The Palazzo Reale (Royal Palace) is located on the central Via Balbi, which unites Piazza della Nunziata and Stazione Principe in a long straight path. The Strada Nuovissima, or "Very New Road" (because it was built immediately after the *Strada Nuova*, or "New Road", today called Via Garibaldi) was built by the banker Stefano Balbi as an appropriate space for the aristocratic palaces that were otherwise cramped within the *caruggi* of the city centre.

In the 1600s, Palazzo Reale was therefore the aristocratic home of the Balbi family. When the family experienced a financial crisis, they sold it to the Durazzo family.

However, the palace beccame *reale*, or "royal", only 200 years later, when upon Genoa's annexation to the Kingdom of Sardinia in 1815, it was sold to King Carlo Felice and transformed into an actual palace.

Unlike the museums on Via Garibaldi, Palazzo Balbi has retained its original furniture, frescoes, paintings and objects, thus allowing visitors

to truly step into the past. Particularly enticing are the elaborate clocks and Chinese vases brought to Genoa by the Savoia family, who were great collectors of these refined objects.

Examine the lovely tables that seem to be topped by marble; upon a closer look, you will see that they are actually made of wood, painted to imitate marble. The precious tapestries depicting Biblical stories on the walls are really cloths painted with a technique based on watercolors and herbal dyes. The Veronese's Supper on display is actually a copy, made when the Savoia decided to transfer the original painting to Turin. According to legend, the Genoese opposed the transfer so harshly that the painting had to be transferred at night; unfortunately, a violent storm broke out, which ruined the face of Jesus in the original picture.

Upon exiting the room, visitors may be forgiven for wondering whether they are actually in Versailles or thereabouts: a spectacular "hall of mirrors" appears to be a smaller-scale reconstruction of the Sun King's famous hall. Visitors walk into an elongated space filled with marble sculptures, windows and mirrors on both sides. Elegant seats are placed between each window, and their backs form a single uninterrupted structure with the mirror. The frames are gilded relief plasters, while the bas-reliefs are monochromatic paintings that imitate marble chiaroscuros. The frescoes painted by Domenico Parodi are particularly worthy of note (most of the frescoes in the palace are his work), as are the sculptures of Filippo Parodi, made in the 1600s and that stand alongside ancient Roman statues and copies of Greek statues. After the hall of tapestries and the delicate Hall of the Aurora, visitors reach the beautiful terraces embracing the gardens. This vantage point affords an unusual and fascinating view of the palace, which is more sumptuous than traditional Genoese aristocratic homes and bears elements of the Roman style introduced by Carlo Fontana.

Fontana was an architect and scenographer from Ticino (Switzerland). He also changed the doorway, atrium and stairways, and added the courtyard and the hanging gardens overlooking via Prè and the basin of the Old Port. His interventions turned the building into a stunning complex.

From the terrace, which offers a suggestive view of the port, there was once a bridge to a terrace directly overlooking the sea. This bridge was demolished in the 1960s to accommodate the causeway.

The palace's rooms, such as the majestic Hall of the Throne, display the echoes and splendours of times past – although not too long ago[17].

Portofino

. .

For centuries, the small church of San Giorgio has been perched atop the isthmus, overseeing two destinations, two destinies for mankind: the open seas, and the sea enclosed by the town's port. The open seas, towards one departed, and the closed sea, towards one returned.

According to historical records, the church was the only one in the world to perform a special ceremony: before leaving for long journeys, Portofino's sailors were blessed by Saint George, the soldier and martyr who had been beheaded by the ancient Roman Emperor Diocletian in Nicomedia, the knight of God who slayed the dragon representing evil.

Over the centuries, the promontory where Castello Brown currently stands bore witness to innumerable changes. The site's strategic location along the coastline certainly fostered the succession of fortifications that were built here, from an ancient Roman watchtower (100-200 CE) to an actual castle, which historians date back to 900 CE. This castle proved to be strategically and militarily crucial when in 1435, it played a pivotal role in saving Portofino from an attack waged by the Venetian fleet.

[17] In Turin, there are the Savoia royal palaces of Agliè, Racconigi and Stupinigi and the Reggia di Venaria, the castle of Govone and the royal manor of Pollenzo.

✠ A tale from Portofino

On 23 April 1945, the feast day of Saint George, patron saint of the city, Portofino gravely risked being reduced to a heap of rubble, if not for a Scottish baroness, Jeannie Watt, who at the time was 79 years old and the widow of the German diplomat Von Mumm (who had passed away in Portofino on 10 July 1924). Baroness Watt unintentionally became the protagonist of the dramatic events that unfurled in the days just before the Liberation of Italy, events that were perhaps the epilogue to a colossal international spy story.

With Operation Sunrise, which later became Italianized into Operation Aurora, the US intelligence intended to block the Third Reich's Operation Zeta, which was to completely destroy innumerable industrial, strategic or otherwise important installations on Italian soil. However, the danger was fortunately averted, precisely on the feast day of Saint George – which also happened to fall on the eve of the Liberation[18].

Baroness Watt lived in Castello San Giorgio, which was positioned towards the eastern tip of the promontory. Her husband had bought it in the autumn of 1910 from a Britishman, Stephen Leech.

Despite the injunctions imposed from Berlin, a German official, Guido Zimmer, had been appointed by Karl Wolff, the head of the SS forces in Italy, to secretly negotiate Germany's surrender. The steps of the "plan" were carried out starting from 26 October 1944, after a secret meeting held one night in the Nazi headquarters in Verona.

Baroness Watt asked to meet Commander Reimers, who immediately agreed. She declared to him: "Sir, we are aware of your plan, which makes nothing of both the beauty of the sites and the safety of its inhabitants. To destroy Portofino is silly, or rather folly, not military strategy. And have you not spared a thought for the population?".

[18] Delpino. *Operazione Sunrise. L'ultimo miracolo. La vera storia della baronessa che nell'aprile 1945 salvò Portofino dai nazisti*, p. 8.

"Baroness," the Commander coldly replied, "I do not know how you came to learn of the plan, but my orders are clear. I can only grant a grace period of a few days to draw up an evacuation plan for the city. However, time is running out and I can wait no longer. When the time will come, I promise to inform you, so that you may save the population. But I am warning you: the decision is irrevocable. Now, if you will allow me, I must kindly ask you to leave. I have listened to you and granted you some of my time, especially because you are the widow of a German diplomat. But now, I beg your pardon, I must leave…"

After a few days, many of the inhabitants of Portofino sought refuge on the Mountain, fearing the worst. But Baroness Watt remained steadfastly in her castle. On the morning of 21 April, once sailor spies had confirmed to her that the Germans intended to leave town early the following week, the Baroness asked for a second meeting with Commander Reimers. "Sir, I too am 'German', but I have been living in Portofino for many years and I can tell you that I have had much time and means to enjoy the gifts it offers to all those who visit it. I think that you too have enjoyed a dawn or a sunset from these cliffs, and you too will have seen the sun rising over the bay. Portofino is not and cannot be a military target. It is a small fishermen's town, one of the most beautiful in the world. This terrible war has spread mourning and terror, has led many things to become forgotten, paving the way for death, suffering, destruction… but the war, Sir, is already over. The English and American troops are at our doors. Destroying this place will serve absolutely no purpose." The German official, disturbed by her words, lowered his eyes and murmured "I am but a soldier, Madam, and I am simply following orders from my superiors. I am sorry. Really, I am…"

At that point, the Baroness firmly continued: "To be a soldier means first and foremost to be a man. And a man cannot be given a foolish and useless order. By destroying this town, you are burdening your conscience with a wrong that will never be forgiven you. Remember my words…"

The German official tried to leave, and the elderly aristocrat shouted after him, almost as a curse: "How I pity you, Sir! You will commit a heinous crime: the evil you are about to do will fall onto you and your descendants!"

The official left and the Baroness, quiet with dismay, trudged slowly and disconsolately along the lane. There was nothing left to do; Portofino would be destroyed[19].

In the seaside town, Sunday 22 April ticked by in complete uncertainty. That Monday, time appeared to stop. At dusk, around 7 p.m., an unusual time for a visit, the bell to the doorway of Castello San Giorgio rang to announce a mysterious character.

The faithful servant Enrichetta, worried and holding a nightlamp, opened the door to a tall young man who spoke in German. Apologizing for the late hour, he asked to see the Baroness immediately. He introduced himself as Klaus.

"Baroness, I am perfectly acquainted with the situation of which you know. But trust me: I am well known here and elsewhere. I have only a few things to say. You have done a lot for this town. But now, you must try to meet Commander Reimer one last time because your concern is mine too. I can assure you that Portofino will not be destroyed if you do exactly as I say. You must speak to him this very night, one last time with Commander Reimer, and make sure you clearly tell him these ciphered words: 'Tomorrow the sun will rise again'. He will understand. Trust me: I will stay here after the war…"

Reimers received the Baroness and her adopted daughter. "Sir, I follow up on my previous meetings with you to say only one thing. I am aware of what is happening elsewhere, but even if I do not understand the international intrigues that are unfolding, I can still bring you a sentence that will surely speak to you: 'Tomorrow the sun will rise again'. Please think about it."

At first, the morning of Tuesday 24 April was dark. But on the horizon, it seemed like a beautiful sunrise would soon break out in all its splendor. In the central square, the German soldiers made a bonfire, destroying only what was strictly necessary in military terms – and nothing more.

[19] Delpino. *Op. cit.*, p. 122.

Many months after the end of the war, the German commander wrote to Baroness Watt from the prisoner camp of Coltano, near Pisa. He wrote that he was "pleased to have heeded her suggestion, that is to not carry out the destruction that he had been ordered to". "Today I can tell you, Baroness, that I had received inderogable orders to blow up the entire peninsula of Portofino. But your words enlightened those last few hours that I spent in that corner of paradise". Through Jeannie Watt Von Mumm, who Reimers later called his "good Angel", Saint George prevented that disaster. On the day of its patron saint, Portofino was also able celebrate the advent of peace.

In January 1983, the Nazi official Ernest Reimers secretly returned to Portofino in incognito, as a tourist. The journalist Aldo Bortolazzi met him in a small hotel in Santa Margherita Ligure. His article was published on the daily *Il Secolo XIX* on 4 February 1983. Reimers told the story of how the town narrowly missed annihilation. The orders of the General Headquarters to carry out Operation Zeta were clear: to blow up the town and the entire peninsula. "If I had lit the fuse, as I had been ordered to do," said the ex-Nazi official, "Portofino and the peninsula would have vanished. That did not happen because I gave in to the pleas of Baroness Jeannie Watt, widow of Baron Alphonse Von Mumm, the owner of Castello San Giorgio, near my offices"[20].

A plaque at the entrance to the cemetery of Portofino, where, in the Protestant section, the Baroness is buried, remembers "Jeannie Watt, widowed Von Mumm 1886-1953, [who] saved Portofino from the destruction ordered by the invading army in March 1945".

Among the most evocative locations in Portofino, Castelletto is worthy of note. From this plateau, which may be reached via an elevator, you may see the entire town and its port. Another beautiful site is the small town of Boccadasse, an ancient mariner's town, whose colourful houses overlook the sea; and the monumental cemetery of Staglieno, where you may take guided tours which explain the important funerary monuments illustrating the work undertaken by the deceased they commemorate (such as the toga-clad statues on the lawyer's tomb, and his wife wearing traditional dress),

[20] Delpino. *Op. cit.* p. 172.

or the statue of the famous peanut vendor. Other artwork portrays the charitable work done by the deceased when they were alive, or the afterlife and the moment of death.

Important personages such as Nietsche, Maupassant, Mark Twain, Empress Sissi of Austria and Ernest Hemingway have always visited Staglieno and left a trace of their passage in the monumental galleries. Each one of them remembered how impressed and fascinated they were by this place, which unites public and private memory with a unique blend of monuments, sculptures and nature.

On the walk, visitors may admire all the artistic styles ideated over the course of over a century, from Neoclassicism to Realism, from Symbolism to Art Liberty and Art Déco. Many monuments were created by sculptors of national and international renown: Santo Varni, Giulio Monteverde, Augusto Rivalta, Lorenzo e Luigi Orengo, Leonardo Bistolfi, Demetrio Paernio, Edoardo De Albertis, Eugenio Baroni, and many more[21].

A few words will be devoted to the funerary monument sculpted by Varni in 1864, the Bracelli Spinola tomb. A figure representing Faith (in exquisite Neoclassical style) leans over the coffin, surrounded by two allegories: Eternal Rest (who may be identified by the crown of poppy seeds and the circle) and Hope (who guards Faith and holds an anchor). The tomb, sculpted by P. Costa in 1870, holds a particularly touching meaning. The sculpture shows a young woman alive on an unmade bed, captured in the act of sweetly, almost pleadingly, grasping the hand of another woman who is standing in front of her and pointing towards the sky. Indeed, the tomb was of a young woman who died in the prime of her youth, just before her wedding day. This is why Costa portrayed her as if she were asking for more time. Staglieno is also the resting place of Constance Lloyd Wilde, Oscar Wilde's wife.

Porto Venere is a UNESCO Heritage site. The legend goes that in 1822, Lord Byron swam from Porto Venere to Lerici to meet his friend Percy B.

[21] Comune di Genova. Ufficio Sviluppo e Promozione del Turismo. *Cimitero monumentale di Staglieno*. P. 3.

Shelley and his wife Mary, who were staying at Villa Magni in San Terenzo. In his honour, the splendid Arpaia grotto of Porto Venere was also called the Byron grotto, because Byron would meditate and gain inspiration for his literary work here; also, a plaque here commemorates his daring feat. In addition, an international open-water swimming competition dedicated to Byron and his exploit is held every year in Lerici. For over 50 years, professional and amateur swimmers from all over the world have swum across the 8.8 km between Porto Venere and San Terenzo.

Sestri Levante is also worthy of note. Arthur Andersen called it the "Bay of the Fables". Every year, the Andersen Festival takes place here, a prizegiving event for fable writers.

The seaside walk of Nervi is also evocative, while the San Fruttuoso Abbey is one of the loveliest places of the entire region, as human enterprise integrates perfectly with the uncontaminated, verdant greenery around it. On this beach, in 711, Prosperus, Bishop of Tarragona, built a church and a monastery to host the sacred relics of Saint Fruttuoso and of his deacons Augurius and Eulogius (Spanish martyrs of the 3rd century), which Prosperus himself saved from Saracen wrath in Spain. The relics of the holy martyr Fruttuoso came from Tarragona, in the amphitheatre of which Fruttuoso and his two deacons were burnt at the stake, during the persecutions conducted by the emperors Valerian and Gallienus.

The complex also hosts a museum on the history of the abbey and the Benedictine monks.

Today, it is also a cultural and entertainment space. The abbey and its tower, built in the 1500s, are the location of temporary art exhibitions; in summer, classical music concerts are held in the courtyard, and a ferry service is set up especially to accommodate the concertgoers.

Those who would like to see dolphins and whales in their natural habitat may take a ferry for the Ligurian Sea Cetacean Sanctuary from the Port of Genoa.

Matera: Modern Yet Prehistorical

MATERA IS AN emblematic city for Italian culture. It is known throughout the world as "the Stone City", because it was entirely sculpted into the calcarenite rocks, known locally as *tufa*. To walk down Matera's streets, alleys and paths is to trace the origins of human civilization, from prehistorical times to our days. These are places inscribed in nature, and among the first to host human settlements. Matera's architecture speaks of centuries of history, which have been passed down to us thanks to copious preservation efforts. The evidence of the very first human presence in Matera dates back to Paleolithic times, as confirmed by the archaeological findings in the Bat Cave. The Sassi (or Stones) of Matera are the site of a primordial dwelling system perched on the slopes of the Gravina, a deep valley with unique and grandiose natural characteristics.

The scarcity of natural resources, the need for collective and appropriate use thereof, the economy governed by the land and by the water supply, and the need to control the energy released by the heat and the Sun were the guiding principles of life on the Sassi of Matera. Human intervention did not only follow the environment; it transformed it, in a stratification of actions based on a harmonious system of management.

The first villages appeared in the Neolithic period. These were the first stable settlements, in which techniques to collect water developed: bell-shaped tanks and narrow channels were enclosed within deep circular moats which did not serve a defensive purpose but were, rather, functional to livestock-raising and agricultural practices. The growing environmental problems made it necessary to create a new construction system, on the model of the *corte a pozzo* (roughly, courtyard-well). The novelty of this system lay

in the fact that its inhabitants collectively used an uncovered part of land, surrounding which modest, usually one-room dwellings in *tufa* or stone would be built. The floors of the dwellings would be made of calcareous rock and serve multiple purposes (sleeping quarters, but also kitchen and living room), and contained simple oak or olivewood furniture.

This model, which is well known in other, distant, parts of the world – such as Matmata in Tunisia or the arid Chinese steppes – is the basis of the courtyard model used by the Sumerians in the Classical and Islamic world. The dwelling excavated near the Neolitic site of Murgia Timone, across the Sassi, illustrates its advantages. The rectangular floorplan, which resembles that of Crete's *megaron*, is divided into three spaces, two open-air rooms and one hypogaeum. The courtyard serves as a collecting space for rainwater and as a sunny, open-air space, which is nevertheless protected from the side, where food preparation can take place. The cavities maintain a constant temperature throughout the year and provide an ideal shelter for humans and animals, as well as a space for conserving produce and water.

What were once irrigated fields and farmyards became a meeting place for extended family and the community and society at large – the neighbourhood. In the courtyard, a great common tank would be carved, collecting rainwater from the roofs. These would form a single piece with the walls, which made it possible to use every single drop of rain, which would be channeled into the tank through terracotta pipes. The lateral runoff pipes were also the stairs and vertical connecting lines within the urban settlement. The network of paths and alleys developed around the channel system, a factor that explains its intricate, apparently inscrutable design.

The urban settlement remained essentially untouched until the 1900s. In modern times, the capacity to manage natural resources in communal terms, and that the water collection network fell into disuse and the city became overcrowded. In the 1950s, the degradation was such that all 20,000 inhabitants of the settlement were transferred to new housing and the Sassi became a ghost town, the largest wholly deserted historical centre in Europe. The study commission appointed in 1952 registered 3,329 dwellings, covering a surface of approximately 300,000 square metres. No

longer inhabited, the homes quickly fell into ruin. Collapses and burglaries were common, including of the Sassi's churches, which were decorated with splendid medieval frescoes. Following the mass mobilization of intellectual and cultural personages, in 1986, the Italian Government enacted a special law allocating 100 billion Lire for the restoration of the Sassi, to be used for carrying out restructuring and urbanization works and to incentivize private parties to move back into the settlement. The funds were entrusted to the City of Matera, which was also granted a license over all of the State-owned properties of the Sassi, the majority of the spaces therein.

In 1993, the Sassi were the first location in Southern Italy to be included in the UNESCO list of World Heritage sites and became a national and international tourist attraction. The applications to return to live in the Sassi multiplied and the prices of the homes and of the remaining private grottoes rose exponentially: first tenfold, then a hundredfold. The City of Matera connected the Sassi to the water, sewer, gas, electricity and telecommunications networks, thus laying the foundations for their extensive use as housing. Today, more than 4,000 people live in the Sassi and dwellings are being renovated to accommodate 8,000 more inhabitants. The Sassi of Matera have thus become one of the most important urban regeneration projects of the Mediterranean region.

The Sassi are an architectural paradigm of a civilian and community-based way of life in which social relations were prioritized, enjoying sufficient room to develop and continually strengthen, in harmony with the environment and the sound management of natural resources. It is this overall vision that should direct the city's management, turning it into a role model for sustainable renovation and management. Through the innovative use of traditional technologies, such as the recovery of the rainwater tanks, the regeneration of the hanging gardens to enhance the city's greenery, and the reconstruction of the grottoes and hypogaeums to enjoy natural ventilation, the renovation efforts became a laboratory of excellence and a centre for the circulation of advanced knowledge. In Matera, one may explore each stage of the history of humanity, as well as study urban regeneration techniques that, inspired by a millenary past, find highly innovative solutions.

✻ The Sistine Chapel Of Rupestrian Art

The Parco della Murgia Materana is home to approximately 150 rupestrian churches. Precious treasure troves dug out from the *tufa*, the churches hold centuries of history, as told by the spaces created and frescoes painted within them. Due to the geological shape of certain areas, however, it is recommended to visit them with an excursion guide. One of the more recondite churches is the Crypt of the Original Sin. Close to the Appian Way, crossing the quiet Pietrapenta path nestled among vineyards and wheat fields, one reaches the Crypt of the Original Sin, a natural cave in a cliff overlooking Gravina di Picciano.

This exceptional rupestrian church is one of the oldest examples of rupestrian art in southern Italy. Its extraordinary frescoes, painted 500 years before Giotto was alive, highlights the typical features of Benedictine art of the region, which underwent the strong cultural influence of the Longobards (8th-9th centuries CE). The theological and artistic value of the murals is such that the church has been called the Sistine Chapel of rupestrian wall art.

The humble painter of the frescoes, whose name is unrecorded but who is remembered as the Painter of the Flowers of Matera, depicted the first chapters of the Book of Genesis on the back wall: God as Father and Creator, Light, Darkness, the creation of Adam, the birth of Eve, temptation and the Original Sin. Under the panel featuring the Creation, in the apse's three cavities, are painted three splendid trios: the Apostles (Peter, Andrew and John), the archangels (Michael, Gabriel and Raphael) and the veneration of the Virgin Mary by two saints.

The Belvedere path is particularly evocative. From this path, tourists may enjoy what is one of the most fascinating and splendid panoramic walking paths of the Parco della Murgia Materana in Gravina di Matera, just across the Sassi, walking past many churches and rupestrian complexes.

Milan: Fashion Capital And More...

MILAN IS KNOWN as a fashion capital. Surely, the fashion quarter, or *Quadrilatero della Moda*, is not to be missed, given the design and quality of the clothes on offer here (although not always at accessible prices). However, the city also holds a wealth of art and architecture.

✱ The Duomo

• •

Religious core and symbol of the city, the Duomo consecrated to Santa Maria della Natività (St Mary of the Nativity) towers above the 1800s piazza of the same name where the bronze equestrian monument to King Vittorio Emanuele II also stands. Built in marble and decorated in the late Gothic style, the Cathedral's dimensions are spectacular (158 metres long and 93 metres wide, spanning over 11,000 square metres). The façade, which dates back to the 1600s, is divided into five spans by six buttresses adorned with statues and spires. The supporting bases are decorated with reliefs of Biblical or allegorical subjects (17th-19th centuries). The sides and the apse of the Duomo afford a complete overview of 14th- to 19th-century statue art, and are topped by 135 spires (the oldest one, the Carelli spire, was created in the early 1400s). The interior of the Duomo reflects the canons established during the Counter-Reformation. The floorplan is a Latin cross with five naves (the central one being twice the width of the

others) and includes a three-nave transect and a presbytery flanked by two rectangular sacristies.

The space is divided by 52 gigantic bundled columns, most of which are topped by capitals and niches bearing statues of saints; these, in turn, are crowned by cusps decorated with statues of the prophets. The windows are decorated with polychromic stained glass. The floor, in marble and stone, was started in 1585 and completed only in the 1950s, and is decorated with polychromic inlays. On the opposite façade, you may admire the main doorway (17th-19th centuries) at which sides are statues of Saint Ambrose and Saint Charles.

Another tabernacle, which is marked with a small red light at the top of the immense vault, holds the Holy Nail of the Cross. Under the Cathedral, there is a beautiful circular crypt through which one may reach the *Scurolo* of Saint Charles (1606), an octagonal chapel that hosts the crystal urn with the saint's relics.

✱ The Pinacoteca Di Brera (Brera Art Gallery)

The Pinacoteca di Brera was founded under the Napoleonic government to rival the national museums that were being created at the time, such as the Louvre. Some of the works on display at Brera are the only surviving evidence of monastic or convent complexes that Napoleon had demolished. The Pinacoteca di Brera was officially inaugurated on 15 August 1809, the day of Napoleon's birthday. Canova's statue of Mars the Peacemaker, dramatically positioned near the entrance to the museum, at the centre of the majestic room on 1500s artwork, was to underscore the strong link between the Emperor and the museum's origins. Napoleon, at the time King of Italy and Emperor of France, wanted to create a museum that would glorify his power, and for this reason contributed to Milan's position as an important centre of artistic masterpieces, mostly from central and northern Italy (especially the Veneto and Lombardy) and dating from the 15th to the 18th centuries. After the Unification of Italy, the Pinacoteca also

received artwork by contemporary painters, masters and apprentices of the Milanese school.

The Pinacoteca hosts many masterpieces. Visitors may admire Andrea Mantegna's The Dead Christ and Three Mourners (1430-1506). The composed body, depicted from an unusual perspective, is laid out onto the stone for the funerary preparations, covered only by a shroud. Three mourners gather on the left: John, the elderly mother and a pious woman, perhaps Magdalene. The painting's chromatic range is reduced to the bone: greys, browns and ochres, which reveal realistic details. The head of Christ was painted larger than would be required to render the scene accurately, to ensure its good visibility[22].

Room XXIV hosts three masterpieces by Piero della Francesca, Raphael and Bramante. The three artists all have a strong connection to the duchy of Urbino, which was Raphael's birthplace and the city where both he and Bramante received their initial artistic education; for Piero della Francesca, the city launched him towards an important moment in his career. The extraordinary works of art are displayed on different walls, illuminated with specifically engineered lighting.

Christ at the Column, painted by Donato Bramante (1444-1514) dates back to shortly after 1490. Bramante combines the spatial illusionism typical of the Urbino School with Leonardo's studies on anatomy and movements of the soul. The light emphasizes realistic details of the statuesque nude, such as the tensed muscles, His reticulated veins and the transparent tears that streak His face.

The Pala of San Bernardino was painted by Piero della Francesca (1413-1492). A milestone in Italian art history, and dating back to before 1474, it reached Brera in 1811 from the church of San Bernardino in Urbino. The iconography is that of the Holy Conversation, with the Virgin Mary and the Holy Infant surrounded by saints and angels, within a Renaissance church. In the foreground, kneeling in piety, is Federico da Montefeltro, Duke of Urbino. The daylight emphasizes the volumes of the solemn,

[22] Strada. *Pinacoteca di Brera*. Skira. 2010. P. 37.

immovable figures, as well as the minutest details. The extraordinary effects of light, shadow and material rendering are obtained by very thin and transparent layers of oil paints.

The Marriage of the Virgin, which was signed and dated on the arch of the portico surrounding the temple, is a masterpiece painted by Raphael during his youth. It was painted for the Albizzini chapel dedicated to Saint Joseph in the church of San Francesco, in the town of Città di Castello. The ceremony takes place in the foreground, with the presence of Mary's friends and her suitors, who had all lost out to the miraculous flower budding from Joseph's cane. The setting is a city square, the vanishing point of which is the doorway of the classical building that opens out onto the gentle Umbrian countryside.

The Supper at Emmaus (1605-1606) of Caravaggio (Michelangelo Merisi, 1571-1610) is one of the Lombard painter's most important works, and was painted shortly after he escaped Rome because he had committed a murder. Of the Gospel story, Caravaggio emphasizes the characters' psychological reactions: in a half-lit space, Christ, mature in age and bearing marks of suffering, has broken and blessed the bread. The disciples have just recognized him and are dumbstruck, while the innkeeper and the elderly servant witness the miracle, entirely unaware. The ray of light exalts the faces, the gestures and the few elements composing the still life scene on the white tablecloth[23].

Francesco Hayez's painting "The Kiss" is very famous. It is one of the Pinacoteca's iconic works, and perhaps one of the most beloved Italian 19th-century paintings. It has enjoyed immense popularity from its very first public display to our days.

[23] La pinacoteca di Brera. *Op. cit.* P. 133.

✽ The Castello Sforzesco (Sforza Castle)

• •

Between 1358 and 1368, Galeazzo II Visconti had a fortress erected, which took the name of Castello di Porta Giovia, from the name of the nearby gate to the city. His successors began to live in the castle in 1412 and expanded it, all the while retaining its defensive purpose. It was the ducal residence from 1466 throughout the 15th century. Enriched and ornated, it soon became one of the most refined courts of the time, also thanks to the work of artists such as Vincenzo Foppa, Leonardo and Bernardino Zenale, who decorated its interior rooms.

The complex has a square base, each side of which is 200 metres long. It is surrounded by a moat (which is now dry). The main façade has two angular cylindrical towers, and at the centre, a gateway topped by the tall Filarete Tower (which was reconstructed in 1905 by Beltrami).

Like the main façade, the other three sides of the complex are decorated by a crenellated rampart and by mullioned windows restored in the 1800s, and each side has its own doorway. The inside is divided into three parts: the broad Courtyard of Arms, which may be accessed from the main entrance, is the castle's original core; the Rocchetta (on the left), which is constituted by a group of buildings facing out onto a splendid courtyard designed by Filarete, Bramante and Ferrini), where the Sforza family would gather at times of greatest danger; and the Ducal Courtyard, designed by Filarete (on the right), where the ducal family's private apartments and receiving parlours were found. Leonardo himself also worked on the internal decorations.

✽ The Darsena And The Navigli

• •

A short distance from the Neoclassical atrium of Porta Ticinese, erected between 1801 and 1814 by Luigi Cagnola, the water basin of the Darsena opens out onto the city. It is also called the "port of Milan", as it had

performed such a function in the past (the great blocks of marble for the Duomo arrived here, from the Lago Maggiore), and was built in the early 1600s by the Spanish governor of the time and then expanded and changed in 1920. The Naviglio Grande merges with the basin. This *naviglio* is the oldest one of the city (construction commenced in 1777-1779) and was the most important in terms of the development of Milan's transportation and trade: 50 kilometres long, it connects with the Ticino river and thus with the Lago Maggiore).

Other than being a gathering site for artists and stands, the Naviglio Grande also hosts regular river competitions. Indeed, some of the most historically important canoe clubs have their headquarters along the waterway. Shops, painters, antique dealers and taverns have inaugurated a tradition of gatherings and entertainment spots that have today proliferated along the Navigli. In addition, along the two Navigli, there are many signs of the (long-past) times when there were several religious buildings. On the Naviglio Grande, there was the church of San Cristoforo sul Naviglio, which was built in the 13th century; and on the Naviglio Pavese, the Red Church, built in the 9th or 10th century.

✠ Basilica Of Santa Maria Delle Grazie

The construction of this basilica began in 1463 with a project of Guinforte Solari. Already in 1492, it was profoundly amended by Bramante upon the orders of Ludovico il Moro.

The interior features three naves, divided by ogive-shaped arches resting upon columns. The vaults are entirely frescoed and its sides presents chapels decorated with important frescoes and paintings, among which that of Holy Mary of Grace, which is actually older than the basilica bearing its name. The tribune and the presbytery are also richly decorated; from here, visitors may access the beautiful courtyard designed by Bramante. The refectory exhibits the renowned Last Supper, painted by Leonardo.

❦ Da Vinci's Last Supper And The Apostles' Conversation

• •

Vinci was a castle and a seigneury in Valdarno, near Florence. In the mid-15th century, it was owned by a notary named Piero, who had an illegitimate child on 15 April 1452, from a woman whose identity remains as yet unknown. This child, called Leonardo, displayed great passion and skill in the figurative arts, such that he was immediately sent to Florence for an apprenticeship under Verrocchio. Here, Leonardo very soon surpassed his master. The young Leonardo was then called to prove his talent at the greatest courts and capitals of the time: in 1482 in Milan, for the Sforzas; in 1499 in Venice, for the Medicis; later in Rome, again Milan and, finally, in France, at Amboise, where he will die on 2 May 1519.

An eclectic genius who displayed extraordinary talent as a painter, architect, scientist and writer, Leonardo also conducted groundbreaking research in the field of mechanics, anatomy, optics, chemistry, geology, astronomy and architecture.

Leonard went to Lombardy, where, after the death of Duke Francesco Sforza (1401-1466) his successor Ludovico, nicknamed "il Moro", sought to honour his predecessor and himself and suggested celebrating his government through works of art. Ludovico il Moro also commissioned the painting of the Last Supper, which was originally painted on the wall of the Convent of Grace in Milan. It is now located in a museum next to the Church of Santa Maria delle Grazie.

One should first consider the site where the fresco was first painted, because it is in this connection that the artist's genius shines in all its splendor. For a refectory, there was no more appropriate and noble image than that of a "goodbye" dinner that the whole world, for all time, was to consider sacred.

"We have, in our travels, seen this refectory, several years ago," wrote Goethe, "yet undestroyed. Opposite to the entrance, at the bottom, on the narrow side of the room, stood the Prior's table; on both sides of it, along the walls, the tables of the monks, raised, like the Prior's a step

above the ground: and now, when the stranger, that might enter the room, turned himself about, he saw, on the fourth wall, over the door, not very high, a fourth table, painted, at which Christ and his Disciples were seated, as if they formed part of the company. It must, at the hour of the meal, have been an interesting sight, to view the tables of the Prior and of Christ, thus facing each other, as two counterparts, and the monks at their board, enclosed between them. For this reason, it was consonant with the judgment of the painter to take the tables of the monks as models; and there is no doubt, that the table-cloth, with its pleated folds, its stripes and figures, and even the knots, at the corners, was borrowed from the laundry of the convent. Dishes, plates, cups, and other utensils, were, probably, likewise copied from those, which the monks made use of.

"There was, consequently, no idea of imitating some ancient and uncertain costume. It would have been unsuitable, in the extreme, in this place, to lay the holy company on couches: on the contrary, it was to be assimilated to those present. Christ was to celebrate his last supper, among the Dominicans, at Milan."[24]

Imagine now that you are in the place itself, and try to picture the deep peace that reigns in these monastic dining rooms and to admire the artist who infuses into his painting such violent emotion, such passionate energy.

The disturbance through which the artist shakes the quiet sacredness of the evening table comes from the words of the Master: *There is one among you who will betray me!* He has spoken them, the entire group is agitated; but He bows his head, lowers His eyes, His posture, His arms, His hands, all repeating with celestial resignation the terrible words, strengthening the silence itself. *Yes, verily I say to you, there is one among you who he will betray me.* According to the Gospel of John (13: 21-26) these words immediate produce amazement and a emotional reaction among the apostles. The words of Christ – *"one of you will betray me"* – hit the apostles like soundwaves, bouncing from one to another and causing their many different gestures, their attitudes and movements.

[24] Goethe. *Observations on Leonardo da Vinci's Celebrated Picture of the Last Supper*, G.H. Noehden (transl.), Booth & Rivington: London, 1821. Pp. 7-8.

This results in a sort of sequence by frames that brings action and life to the scene.

With a few brushstrokes, Leonardo concentrates a variety of attitudes, movements, expressions, and meanings.

However, we must first explain the main device that Leonardo used to animate this painting: the hand gestures (which however could only occur to an Italian). In Italy, people's entire bodies are full of spirit, all limbs participate in expressions of feeling, passion, even thought. Through the different positions of the hands, it is as if Italians were speaking. Leonardo, who paid close attention to all characteristic traits, must have turned his inquiring eyes above all to this national peculiarity, such that the painting before our eyes is unique and will never receive enough consideration.

The physiognomies and movements accord perfectly with each other; even the juxtaposition and contraposition of the limbs, which are immediately evident, are rendered in the most commendable way.

The figures next to the Lord are arranged in groups of three. Nevertheless, even they are always thought of in a single group, each related and kept in relation to the neighbors. First to the right of Christ, there are John, Judas and Peter. John, the youngest teenager, is depicted with delicate traits in the full Vincian sense of the term: the beautiful rounded face but also elongated, the hair that is smooth near the parting but that, descending, lean against Peter's extended hand. The young man is placid, immobile, and shows no signs of involvement[25].

Peter, the farthest, upon hearing the words of the Lord, leans forward rapidly behind Judas, driven by his impetuous nature. The latter, looking up in fright, bends towards the table, holding tightly onto the purse in his right hand. In the meantime, Peter has grabbed with his left hand the right shoulder of John, who is bent toward him, pointing at Christ and at the same time inciting the favourite Disciple to ask who is the traitor. He unintentionally points the handle of a knife held in his right hand against

[25] Goethe. *Op. cit.* Pp. 10 ff.

the ribs of Judas, causing to lean forward in fear and spill a salt jar. This group can be considered as the first in the painting's overall design, as well as the most accomplished.

If, at the right hand of the Lord, a restrained movement threatens imminent revenge, the left-hand side shows the liveliest reproach and repugnance for the betrayal. James the Elder leans backwards in fear, stretches out his arms, stares straight ahead as if he could already see, with his eyes, the horror he has just heard with his ears. Thomas peeks out from behind his shoulder and approaches the Savior, raising the index of his right hand to his forehead, as if to ask for explanations. Philip, the third person of this group, endows it with a refined circularity; he is standing up, leans before the Master, brings his hands to his chest, and exclaiming with great frankness: *Lord, it is not me! You know! You know the purity of my heart. It is not me!*

And now the three nearest apostles, the last on this side, provide us with a new subject of observation. They talk to each other about the tremendous thing they have just heard. With an impassioned movement, Matthew turns his face to the left towards his two companions, as he tends his hands towards the Master, thus connecting, in an invaluable artistic sleight of hand, his group to the previous one. Thaddeus displays shows the greatest stupor, doubt and suspicion: he lays his left hand on the table with his palm open and raises his right hand if he was about to backslap someone... a gesture that simple people still make when, faced with an unexpected event, they want to say *I told you! Did not I always suspect that?* Simon sits with great dignity at the head of the table, and we therefore see his full figure. He is the oldest of all the apostles, and is dressed in a rich drape; his face and movements indicate that he is thoughtful: not dismayed, simply moved.

Now let us turn to the opposite end of the table. We may see Bartholomew standing, as he rests on his right foot, which he overlaps with his left, supporting his body by propping himself up comfortably with both hands on the table. He is listening, probably to hear what John will ask the Lord; because the initiative of the beloved apostle appears to arise from this entire

side of the table. James the Younger, next to and behind Bartholomew, puts his left hand on Peter's shoulder, as does Peter on John's shoulder; but James' gesture is calm, a mere request for explanations, whereas Peter already threatens revenge.

And as Peter behind Judas, so James the Younger stretches his hand behind Andrew's shoulders, which, being one of the most significant figures, lifts his arms up halfway to show the palms of his hands in a clear manifestation of fright[26]. Leonardo's primary intention was to depict the "movements of the soul".

If this sequence of spiritual motions and reactions in terms of attitudes and physiognomies is what Leonardo intended to consign to history as an accomplished materialization of his programmatic manifestation (which perfectly adhered to his vision of a passage of the Gospels), the word of Christ, the Word of God, animates the scene and imprints life and motion to the universe all over.

The painting is rich in meaning and symbolic allusions, one of which is the establishment of the Eucharist. The traditional theme of the Last Supper was an obligatory choice, as a theme suitable to be depicted in a refectory; but Leonardo also merged within it the results of over a decade of studies and research, as well as other references to the Passion of Christ; the offering of himself in sacrifice, through the indication of bread and wine, also mentions for example the Crucifixion painted on the opposite wall of the Refectory of Montorfano; Christ's very position (we also imagine seeing his feet before the door below was opened) contains a direct allusion to the Crucifixion, with open arms and feet, slightly overlapping. At the same time, bread and wine, material foods for the dining monks, become their spiritual nourishment after the Passion has come to fruition[27].

[26] Goethe. *Op. cit*. P. 12.

[27] Marani. Skira. *Il cenacolo di Leonardo*. 2009. p. 32.

✲ Villa Litta In Lainate: The Renaissance Water Features.
• •

Count Pirro I Visconti Borromeo decided to build a palace, which was to remain separate from his residence and was to preserve the art collections of the Visconti Borromeo Litta family. The palace had a garden and a nymphaeum. The rooms of the Nymphaeum were created by the architect Martino Bassi (who also worked on the construction of the Duomo) and were also intended for entertaining guests who, accompanied on a journey through mosaics and unexpected water games, were amazed at how their hosts were powerful and "modern". Among the many designs, there are unicorns, bat-winged dragons, giant snails, angry geese, dragon-dolphins and other bizarre and grotesque characters.

Along the Cortino della Girandola, a corridor guarded by frightening dragons, we were surprised by water spurting out from who knows where...

After the Galleria delle Romane, visitors find themselves in a large courtyard, at the centre of which is a green marble column. It is perforated inside, to allow water to climb up and sprayed by the mouths of the angels carved above the capital.

In the past, fantastic water features must have been on display. It would look like water was pouring out from all around the courtyard's cornice, recreating different types of rain depending on its intensity, from drizzles to thunderstorms. On some sunny days, one could even witness beautiful rainbows, perhaps more than one at a time.

In this courtyard, in ancient times toasts to the new crop and the new wine production were made. In fact, references to wine, grapes and vines may be seen everywhere.

The Old Caves are the most striking part of the entire visit to the Nymphaeum. These are artificial caves, entirely made of *tufa* and travertine. Here, too, water features lurk, both from above and from below.

Towards the end of the 1500s, Agostino Ramelli, a retired military engineer, went from a lifetime inventing war machines to creating fascinating hydraulic machines. He was immediately commissioned by Pirro I to design a water feature system at his country villa. Ramelli thus designed the Water Tower, the heart of the Nyphaeum. Inside the tower, there is a reservoir that can hold approximately 7,000 liters of water. The piping system, almost 1 km long, feeds nine waterfalls, murmurs and 53 features.

In Milan, the Navigli are particularly suggestive in the late afternoon-early evening, with eateries and bars where patrons can enjoy an excellent dinner or lunch of exquisite local dishes.

Napoli Parthenopea: Naples And The Siren Parthenope

T HE MYTH OF the siren Parthenope or Partenope (in Greek, Παρθενόπη) is part of the traditions of the Cumani people, of Greek origin. The name of what is said to have been the most beautiful mermaid of the Gulf of Naples, who according to legend was buried nearby, is used today to define the Neapolitan region. It seems that the siren in question died on what today is the site of Castel dell'Ovo; on the same location, one of the patron saints of Naples, Saint Patricia, was also buried there.

The royal palace is located in Piazza del Plebiscito, and the royal complex also includes the nearby San Carlo theater. The 184 boxes, spread over six storeys, surround the royal box, which could be more accurately described as a salon, with fifteen armchairs and overlaid by a large crown. Thousands of candles bordered the stages and reflected on mirrors. The San Carlo is still the theater with the largest seating capacity (3,000 spectators). With its chandeliers, drapes and gold, silver and blue colors, and the possibility to open the stage backdrop onto the gardens of the Royal Palace, the theater enchanted all those who crossed its threshold. In 1729, Montesquieu defined the stairway of honor as the most beautiful in all of Europe. The theater also featured private apartments for the King and the Queen. From the room of Queen Maria Cristina, Ferdinand II's first wife, one may access the gabled bay roof garden offering a gorgeous view of the Gulf of Naples, the Vesuvius and Capri.

The Santa Chiara complex dates back to 1310, when the new king, Robert of Anjou, accepted the request of his wife (Sancia of Majorca) to build a vast monastery for the Clarissine nuns, who were protected by the queen.

The large 14th-century cloister hosts a refined secular rustic garden, whose two avenues are shaded by a trellis decorated with beautiful blue, yellow and green majolica tiles by Giuseppe and Donato Massa. Bucolic countryside scenes decorate the seats, and festoons of fruit and flowers wrap around the octagonal pillars supporting the vines and the trellis's flowers.

The church, which was intended to host the tombs of the Angevin dynasty, reveals this regal function with its vast dimensions. The construction work was entrusted to Gagliardo Primario, who in 1328 created the tall Gothic nave, the roof of which features timber roof trusses, inspired by the precepts of Franciscan poverty. In the last chapel to the right, the Bourbon rulers of Naples and their family are laid to rest.

Among the tombs in this chapel is also that of Maria Cristina of Savoy (1812-1836). From a book on her life that I bought in the church's souvenir shop, I discovered that she devoted her life to making a positive impact on her society, one in which she saw profound spiritual and material poverty. I knew that she was the mother of Francis II, the last king of the Kingdom of the Two Sicilies. What I did not know, before reading her biography, was that I would find myself the following year at the ceremony of her beatification, in the crimson church of St. Clare. Although I had gone to the church very early, there were no more seats, as these had all been booked long in advance by pilgrims coming from many parts of Italy. Maria Cristina of Savoy (Cagliari, 14 November 1812 - Naples, 31 January 1836), wife of Ferdinand IV, daughter of Vittorio Emanuele I of Savoy and of Maria Theresa of Habsburg, lived between Cagliari, Turin and Genoa.

She wished to enter the monastery of the nuns of the Most Holy Annunciation of Genoa, but for reasons of state and upon the advice of Father Giovanni Battista Terzi, her tutor and adviser, on 21 November 1832, Maria Cristina married Ferdinand II of Bourbon, King of the Two Sicilies. Upon her entrance into the Bourbon household, she found

a deeply tense situation that had been going for several years between Ferdinand and the Queen Mother Mary Isabella. Maria Cristina asked Ferdinand for permission to greet her in her apartments. She soon began to repeat that gesture very frequently until her husband eventually started to accompany her.

Maria Cristina also sought to mend the relationship between Ferdinand and his brother, Prince Charles. When Charles ran away from Naples with the Irishwoman Penelope Smyth, according to the royal system, his allowance was suspended; however, thanks to Maria Cristina's pleas, Ferdinand gave him three thousand ducats per month from his own personal estate.

Ferdinand listened to his wife and allowed many of the good works she sought to introduce. Maria Cristina also intervened with her husband to revoke several death sentences –not only which had been imposed for common crimes, but also for those handed down upon the people who had taken part in the conspiracy against the King on 13 December 1833.

In only three years, she managed to perform many charitable works and social interventions: as soon as she came to Naples, she redeemed all of the pawns deposited at the major pawnshop by returning them to their owners. She donated as much money as she could, often through Father Terzi. She asked parish priests about the needs of the families within their congregation. At the bottom of the palace stairway, she installed a sort of mailbox, where anyone could post a petition; only she had the key and every night she emptied it and provided as she could. The queen met this enormous need for alms from her personal possessions.

She arranged for 240 poor brides of the city to be given the dowry that they could not afford.

Maria Cristina particularly cared for the "San Leucio colony" where silk-work was done. The colony, founded in 1789 by Ferdinand I for silkwork, had fallen into disrepair. The queen convinced her husband that to let those plants collapse would be a "deceptive saving".

Therefore, Maria Cristina planted new mulberry trees for silkworm breeding at her own expense, and began renovating the premises and expanding the factories. She ordered new cutting-edge frames and invited experts from Lyon to educate the colony on the silk production cycle. Finally, she arranged for the distribution and sale of their products in the specialized shops of Naples. The queen began to have dresses sewn with those silks according to Parisian fashion; as this prompted the ladies of the kingdom to do the same, she contributed to increasing their sales. She also supported coral processing in Torre del Greco.

After two years of marriage, the royal couple had still not given birth to a son. Finally, after many prayers, in the spring of 1835 the queen was expecting a baby. On 16 January 1836, the heir to the throne and last king of Naples was born, under the name of Francis II. However, sadly, the queen developed septicemia and it was clear that her life would end in a few days. Maria Cristina was aware of her fate and accepted God's will with serenity. Taking her son in her arms for the last time, she handed him over to her husband saying, "You will answer to God and to the people, now I must think only of God." She died on 31 January 1836. Her funeral was celebrated on 9 February 1836, with a massive crowd participation. Maria Cristina was buried in the Basilica of Saint Clare, where she still rests today. On 24 January 2013, in the same church, which was packed with two thousand people and attended by descendants of the old Italian royal families, Maria Cristina of Savoy was beatified. Even today, the association leading her name continues to pursue her ideals.

✱ The Chapel Of Sansevero

The Chapel of Sansevero was built in 1590 to host the tombs of the Sangro family. Raimondo Sangro (1710-1771), prince of San Severo, was an aesthete and alchemist. The prince enriched the chapel with sculptures that are astounding for the accuracy of the marble details (veils, body parts, drapes that look wet).

Inside the chapel there is the Veiled Christ (1753), a splendid supine figure sculpted by Giuseppe Sammartino – a true pearl of Baroque art.

It was Sangro's intentions – on this and other occasions – to arouse wonder: it was no coincidence that he himself realized that that marble veil was so impalpable and "made with such art to leave astonished even the most skilled observers".

�￦ The Miracle Of Saint Gennaro

The metropolitan Cathedral of Santa Maria dell'Assunta is a monumental basilica, as well as a cathedral and the seat of the Archdiocese of Naples.

The cathedral, which rises in a small square enclosed by a portico and incorporates three other churches that had been built independently from the cathedral: the basilica of Saint Restituta, which houses the oldest baptistery in the Western world, and that of San Giovanni in Fonte, and the royal chapel of the Treasure of San Gennaro, which hosts the relics of the patron saint of the city.

The basilica is one of the most important and largest churches of the city, from both an artistic point of view (it embodies several styles, ranging from pure 14th-century Gothic to 19th-century Neo-gothic) and in cultural terms: indeed, three times a year, the rite of the liquefaction of the blood of Saint Gennaro takes place here.

�￦ The Capodimonte Museum

Since 1957, the Museum of Capodimonte has resumed its function as a museum, one that had already been attributed to it by the Bourbons in the 18th century. In addition to the royal apartments, the museum hosts medieval and modern art collections. Its original core collection, the

Farnese collection, which includes works from the great schools of Italian and European painting from the Middle Ages to the 17th century, was later enriched with works acquired under the Bourbons and after the Unity of Italy, including by some of the great names of Italian and international painting: Raphael, Titian, Parmigianino, Bruegel the Elder, Guido Reni, Caravaggio.

The park is home to the old buildings of the Royal Porcelain Factory, which had been established by Charles of Bourbon in 1739, and are now occupied by the State Professional Institute for the Ceramic and Porcelain Industry.

Particularly impressive is the Spaccanapoli axis, which "splits" the city centre into two and gives its name to one of the oldest neighborhoods of the city, where echoes of Neapolitan popular life still resound. In Via di San Gregorio Armeno, you can still find the characteristic workshops of Nativity scenes, crafted according to the Neapolitan tradition, and representations of famous figures as statues for the cribs.

✠ Surroundings: Capri, Amalfi, Positano

We will now explore some splendid places that can be reached by boat from Naples.

Amalfi.

The origins of the city date back to the Roman Empire. It was besieged by the Longobards and then ransacked by Prince Sicardo of Benevento, who deported its inhabitants to Salerno in 836-839. Upon the tyrant's death, Amalfi rebelled, liberating itself from the yoke of Naples to become the first maritime republic of Italy. As an autonomous and active power, the town controlled the markets of the Mediterranean for more than three centuries: it beat its own currency and promulgated its own laws, including the Amalfian Laws – the first legislative code of navigation, which was later also used by other maritime republics before being adopted by the navy

of the Kingdom of Naples up to the sixteenth century. The cathedral of Amalfi is consecrated to Saint Andrew and was erected in the 9th century. The cathedral is a monumental complex consisting of several autonomous structures, which are however intimately connected with each other. The oldest element of the complex is certainly the Basilica of the Santissimo Crocifisso (Most Holy Crucifix), which was built before the year 833. In 987, the present cathedral was built next to it, giving rise to a single majestic metropolitan cathedral with six naves, which was divided into two churches in the Baroque era. Works on the bell tower were started in 1180 and completed in 1276; the construction of the Crypt, intended to host the sacred remains of Saint Andrew the Apostle, dates back to 1206. The Cloister of Paradise was the most recent structure to be built, between 1266 and 1268. In perfect Romanesque-Amalfian style, it was commissioned by Archbishop Filippo Augustariccio as the cemetery of the Amalfian aristocrats. The interwoven arches supported by 120 marble columns are particularly suggestive; even more so are interplays between the rays of sunshine streaming onto the portico through the arabesqued arches.

The crypt of the tomb of St. Andrew (the first Apostle of Jesus, who died in Patras in Greece, embracing the cross as did his Master) was built in 1206, to receive the sacred remains of the Apostle. These arrived two years later, brought from Constantinople by Cardinal Pietro Capuano, who was the papal legate during the Fourth Crusade. The sacred relics are currently enclosed in a silver urn located under the central altar, which is attributed to Domenico Fontana. The Amalfian people is deeply devoted to Saint Andrew, as they demonstrate twice a year with solemn celebrations.

Capri.

Capri was one of the favourite escapes of the Emperor Augustus, enchanting him in 29 BCE as he returning from the military campaigns waged in the East. The Gardens of Augusts are beautiful. The island later became known as a resort location, but its prosperity reached its peak under the Emperor Tiberius, who lived there for the last ten years of his life. Villa Jovis is the largest and best preserved imperial villa on the island, and was one of the twelve residences that Tiberius built in Capri.

Ischia

The natural springs of Ischia have given rise to several spa facilities, and some beaches, such as Sant'Angelo and Sorgeto, have volcanic water with a temperature of 90° Celsius. A phenomenon of secondary volcanicity takes place at these beaches, manifesting through boiling gas bubbles that emerge from the waters of the coast.

The Mortella Gardens are stunning: in 1956, Lady Walton commissioned the famous landscape architect Russell Page to design the original plan of the garden, asking him to integrate it into the picturesque volcanic rock formations. The Mortella is divided into two parts: a lower garden in the Valley, and an upper garden on the terraced Hill with dry walls; the Gardens extend over an area of approximately 2 hectares and houses a vast collection of exotic and rare plants, which is enriched every year. In terms of variety and wealth of collections, the Mortella Gardens can be considered a botanical garden.

The Gardens are tastefully and skillfully crafted, and full use was made of the beautiful rocks and the views of the Mediterranean sea; it is enriched with fountains, pools and waterways that allow for the cultivation of a superb collection of aquatic plants such as papyruses, flower lotuses and tropical water lilies. The various areas of the garden are linked to one another by avenues, paths, dry walls, slopes and steps, that allow visitors to reach the upper area, from which they may enjoy stunning views of the bay of Forio.

Lady Walton's work in creating this enchanted garden is well known among gardening and plant enthusiasts, to the point that a new orchid hybrid was created in her name: the *Miltassia Lady Susana Walton* can be admired in the Orchid Greenhouse, also located in Ischia.

Ischia also has a beautiful Aragonese castle. Its rocky base is geologically defined as a "dome of stagnation" and is equivalent to a bubble of magma that solidified during larger eruptive phenomena. The dome reaches a

height of 113 meters and expands over an area of approximately 56,000 square meters. It has a magnificent view of the sea.

Positano

The white houses of Positano are terraced on the steep slopes of Monte Comune and Mount Sant'Angelo in Tre Pizzi. This ancient maritime village, founded by the inhabitants of Paestum, is today one of the most famous seaside resorts on the Amalfi Coast. A dense network of alleys and stairs lead to a beautiful beach.

⚜ Pompeii And Ercolano

Scholars trace the beginning of the historical era of the Vesuvius to the famous earthquake of 63 CE described by Seneca. The Pompeiians responded promptly to the catastrophe, undertaking reconstruction work almost immediately, especially on private buildings (such as the Villa of Oplontis, which we will see later). That earthquake was probably a warning sign of the next, terrible, eruption that took place in 79 CE, which had ruinous consequences for Naples, Pompeii, Herculaneum and Nucera. On that occasion too, the volcanic phenomenon was announced with earthquakes; however, when the violence of the subterranean gas and magma managed to reopen the underground duct in which it lay bubbling, the eruption exploded with frightening power. A 2-km tear ripped open the entire flank of the mountain, and a terrible fury of slags, sparks, hot mud, polluting gases, lava, burning stones and ash spewed out, burying monuments and humans beneath a layer of debris over seven feet thick. It was at that very moment, from that very tear, the so-called "Great Cone" took form: the picturesque crater that released, until the latest eruption of 1944, the unmistakable plume of smoke that for centuries was linked to the image of Naples and its Gulf. Because of the eruption, the volcanic duct underwent a considerable shift and the very morphology of the volcano was changed into its present shape. In fact, a fresco discovered in Herculaneum

and two others found in Pompeii all depict Vesuvius with a single peak, as it was, therefore, before the crater of Monte Somma split.

Pliny the Elder witnessed the terrifying phenomenon, and would perish because of his insatiable curiosity as a scholar. From a farther (and safer) vantage point at Capo Miseno, his grandson Pliny the Younger observed the eruption. Later, around 106 CE, he would become the only official historian and write that which is the earliest written testimony in volcanology: two letters in which Pliny the Younger described the details of the eruption as learned from those who were his uncle, as well as everything that he saw himself.

"Soon after, that cloud descended to the ground and covered the sea: it had already wrapped and hidden Capri, and hid from our view the promontory of Miseno. Then, my mother begged me, entreated me, ordered me to flee in any way; she said that I, still young, could succeed, and that she, heavy in age and body, would have had a good death if she would not be the cause of mine. But I answered that I would not save myself without her; then I took her by the hand and forced her to hasten her pace. She obeyed me unwillingly and accused herself of slowing down my march.

Ash begins to fall, but it is still sparse. I looked back: a dense darkness approached behind us and, pouring onto the ground, chased us like a creek. "Let's step away, I tell her, as long as we can still see, to avoid being knocked down by the crowd around us and being trampled in the dark."

We had just managed to sit down when it suddenly became dark as night; but not as a night with no moon or when the sky is covered with clouds - rather, as when the lights are off in a closed room.

You could hear the desperate cries of the women, the calls of the children, the screams of men: some, with their screams, tried to find their parents, children or spouses; they lamented their misfortunes, others those of their loved ones. Others, fearing death, hoped for death; many raised their hands to the gods, but most formed the conviction that the gods no longer existed and that that night would be eternal, the last night of the world.

There was a slight lightening, but it did not look like the light of day, rather a warning of approaching fire. The fire was there, but it stopped quite far from us; then it became dark again and heavy dense ash fell. Every now and then, we got up and shook it off; otherwise we would have been covered by it and crushed under its weight. I could boast that, surrounded by such serious danger, I did not utter a groan or a single word that was less than brave, if I had not been convinced that I too would succumb together with the universe and the universe with me."

Literally vanquished by the devastating fury of the volcano, the city was buried and forgotten for centuries: towards the beginning of 1600, during the drainage of a canal, traces of ancient buildings were discovered, but no one thought of tracing these to the disappeared city. In the first half of the following century, after some fortuitous finds, the memory of Pompeii seemed to suddenly return, so that in 1748, upon orders by Charles of Bourbon, the first systematic excavations were started. Continuing in the following years with varying aims and effort, the excavation works, that were carried out in a scientific and systematic manner only from the end of the last century, brought to light over sixty acres of the surface over which Pompeii was to extend at the time of the catastrophe. The archaeological research continues to this day, with the dual purpose of preserving what has already emerged and making new discoveries. In this way, those same ashes that had choked the Pompeiians in their desperate attempts to escape, or in the equally futile attempt to take refuge inside buildings (as evidenced by casts made of the remains in modern times), and that had caused the death of Pompeii, paradoxically preserved at least part of the life of this large city to our days. Thus, we can see that Pompeii was protected by 3-km long city walls, was prosperous, lively, populous, and busy, abounding in hotels, inns, postal stations, shops of all sorts, grand public buildings, temples and private homes, both modest and luxurious and elegant.

To the south of the forum stand the buildings of the public administration, the headquarters of the *duovirs*, the highest magistrates of the city, those of the *edili*, and the *Curia*, where what we call today the municipal council would meet. Not far away is the *Comitium*, an area dedicated to the conduct of elections. Next is the *Macellum*, a large market with shops and a small

temple dedicated to imperial worship. Also near the square are other public buildings, the temple to August Fortune (a cult that was characteristic of the Roman imperial age), the spas of the Forum and the Basilica.

The Basilica was the heart of economic, civic and commercial activity. Its building, the most grandiose and solemn among Pompeii's public monuments, stretched over a vast area of 55 meters by 24 meters.

Pompeii also had a theater, which was erected in the 5th century BCE and could accommodate about 5,000 spectators. Over the centuries, it was reconstructed several times. Many of these renovation works were possible thanks to the munificence of illustrious Pompeian citizens, such as Marcus Antonius Primus, Marcus Olconius Rufus, and Marcus Olconius Cere.

Next to the theater stands the *Odeion*, a building similar in shape but smaller, destined for less popular artistic performances such as musical auditions, verse recitals and mimes. The *Odeion* could accommodate less than 1,000 people. Next to the amphitheater is a large gymnasium, which is surrounded by arcades and has a pool at its the center: here, gladiators practiced, as testified by many graffiti inscriptions.

The baths, which were also equipped with a gym, were divided into two sections: one for men and another for women, both of which equipped with a dressing room (*apodyterium*) and rooms for cold baths (*frigidarium*) and warm baths (*tepidarium*), a splendid room the vault of which was decorated with stucco panels portraying various subjects. Along the walls, a series of niches are carved, each of which is framed by terracotta atlases holding the refined ornamental frieze, carved with plant intersections. The warm environment (*calidarium*) was ingeniously designed so that hot air could circulate and heat the entire environment.

The houses generally developed around a central atrium, adjacent to which were rooms called *alae*, and that was covered by a four-lobed inward-sloping roof that, thanks to a central aperture (*compluvium*), allowed light to filter into the homes and a supply of rainwater to be collected in an underwater tank (*impluvium*). This would be connected to a cistern. Around the court, where the fireplace the *Lari* altar were located, the

other spaces (*cubicula*) were organized. At the end of the courtyard was the *tablinum*, once a wedding room and later a reception room from which one could access the *hortus*, a mid-sized garden. The meals were consumed in the *triclinium*.

The Faun's House is a remarkable example of Pompeiian private architecture and is dated back to the 2nd century BCE. Its forms recall the Hellenistic style. The wall decorations are simple and elegant, done in polished stucco panels imitating marble slabs. The rooms' mosaic flooring is among the most beautiful known to man; emblematic in this respect is the famous mosaic representing the Battle of Issus between Alexander the Great and Darius, King of the Persians. These mosaics, if not Hellenistic originals, are excellent reproductions. They are conserved in in the Archaeological Museum of Naples.

The house is named after a statue of a Faun, an original Greek sculpture from the 3rd or 2nd century BCE. The statue adorned the *impluvium* and is currently preserved at the archaeological museum of Pompeii.

Menandrus's home is one of the most beautiful Pompeian homes. Its architecture features noble proportions and an articulated and airy floorplan. The façade is adorned with two *tufa* pillars crowned by Corinthian capitals. The peristyle is decorated with paintings depicting theatrical subjects, among which the portrait of the poet Menandrus, one of the greatest comedians of ancient times – hence the name given to the house. From the *Casa del Menandro* comes the rich silverware treasure today displayed at the Archaeological Museum of Naples, consisting of 118 pieces including a full place setting and other tableware, family jewelry and a stash of gold and silver coins for a total value of 1432 *sesterzi*.

✵ Oplontis

· ·

The sumptuous Oplontis abode is also called *Villa di Poppea*. An amphora bears the following inscription: *Secundo Poppeae*, or "To Secundus [slave or *libertus*] of Poppea".

The presence of the Poppea family (*gens*) in the land is documented by many finds and inscriptions. Therefore, it cannot be excluded that the villa did actually belong to that family, or to Nero's wife herself.

This is only a conjecture. However, the beauty of the architecture and of the decorations indicate, beyond all doubt, that it belonged to a very wealthy family. When the Vesuvius erupted in 79 CE, the villa was empty: the excavations did not identify victims or daily utensils. What were found were piles of building and decorative materials, as if the villa were being renovated or expanded following the catastrophic earthquake that ravaged the region in 62 CE. The renovation works may also have been suspended or delayed because of Poppea's sudden death.

The home included a full set of Roman baths – *frigidarium* (cold room), *tepidarium* (warm room) and *calidarium* (hot room), a *larario* (an altar where the *lares*, or ancestors, were worshipped), a rustic peristyle, a swimming pool, wine cellars, an atrium, kitchens and a pantry.

Regardless of whether the Oplontis villa belonged to Poppea or to another wealthy family, it is the most important example of ancient Roman suburban villas.

From its wall structures, it may be concluded that it was built in the first century CE.

The frescoes adorning its walls are perhaps its most striking element, given their vivid colours and exceptional extent. Among the images depicted are a basket of figs, rendered with such extraordinary skill that the fruits seem freshly picked; a glass fruit container, holding pomegranates; a food trolley with a column-shaped stand; and tragedy mask and a peacock,

decorative elements added to a clever game of perspectives portraying Apollo's sanctuary. Through a service corridor, walking through an inner garden and the kitchens, visitors may access the *triclinium*, where the scenographic and decorative elements reach their greatest elegance. On one wall, flanked with columns sumptuously decorated with gold, gems and stylized vines, an elegant doorway is painted, topped by a golden shield and a circular altar, on which a protecting divinity is portrayed. On the background, architecture and open spaces are shown. The other walls are also filled with paintings of architectural structures and ornamental motifs of natural elements and still-life scenes. Through a small atrium hosting a circular fountain, visitors reach the baths, consisting of *frigidarium*, *tepidarium* and *calidarium*.

Among the paintings in the baths, the most interesting may be found in a niche of the *calidarium*. Beneath its intact flooring, the *calidarium* still features the *suspensurae*, the pipings that, together with the gaps between the wall structures, allowed hot air to circulate.

Outside the baths is a wide room which faces the *viridarium* (garden) to the north.

Next to the central building is the eastern part of the villa, which was reserved for the employees' daily lives and work activities. This complex, which had its own separate entrance, had a rustic peristyle at its centre, around which various rooms were arranged. Among the most clearly recognizable structures is a *lararium*, or altar where domestic gods and the ancestors were worshipped; a food pantry; latrines, which featured astounding technical elements to ensure water flow; a long corridor with wide balconies along its walls, most likely workstations for processing harvested products.

The wing to the far south-east hosts rooms for wine production.

✣ The Archaeological Museum Of Naples
. .

Ferdinand IV of Bourbon decided to gather his family's impressive cultural collections. Charles of Bourbon inherited, from his mother (Elisabetta Farnese) an extraordinary collection of artwork and ancient artefacts, marble and bronze statues, mosaics, objects of daily life, precious objects and splendid paintings from the excavations at Herculaneum, such as the *Villa dei Pisoni*'s paintings and library scrolls.

Thanks to these prestigious innovations, Naples, which had become the capital of the new Kingdom, became an obligatory stop of the "Grand Tour", a sort of cultural pilgrimage to Italy that all young Europeans had to take to complete their education.

The Farnese collection was the most famous collection of ancient Roman artefacts. It was initiated by Pope Paolo III Farnese, who promoted the excavations: in 1545, therefore, in a courtyard of the gymnasium of the Baths of Caracalla, the colossal sculptural complex of the "Toro Farnese" and the Hercules returned to light – pieces which represent the preciousness and richness of the Farnese collection. The awe evoked among the artists and cultured men by the retrieval of the sculptures was truly extraordinary.

✣ Mosaics (Memento Mori)
. .

These mosaics, originally inlaid into the *triclinium* of a house in Pompeii, depicted the transience of human life. It illustrates an allegory of the Hellenistic philosophical theme of the transience of life and of death as a leveler of human destinies. At the centre of the scene is indeed a leveler. The axis of the bar is death (the skull), under which a butterfly (the soul) and a wheel (fortune) are shown. On the left-hand side are symbols of power and wealth (a scepter and purpura), while on the right, a symbol of poverty (a traveler's sack).

☃ The Mosaic Of Alexander The Great

This large mosaic (5.82 m x 3.13 m), among the most famous surviving from ancient times, was found on 24 October 1831 in the *Casa del Fauno* in Pompeii, where it decorated a rectangular gazebo that looked out onto the home's central peristyle. The mosaic portrays a battle against Alexander the Great, who, bareheaded, vigorously advances towards Darius III (on the right-hand side, on a fleeing chariot). The famous mosaic is a faithful copy of a great painting of the first Hellenistic era (second half of the fourth century BCE). The breadth of the composition is unparalleled, with masses of men and horses drawn by an overwhelming dynamic emphasized by the contraposition of the long spears against a clear sky. The scene must have been very famous in ancient times, as the subject was also painted on Etruscan urns and in reliefs on ceramic goblets. The technique used is that of the highly refined *opus vermiculatum*: the mosaic contains approximately one million minuscule tiles (15 to 30 tiles per square centimetre).

☃ The Paintings Of The Terentius Neo Couple And The Young Student

The painting of the Terentius Neo couple shows two wealthy, refined, cultured and fashionable individuals. In particular, the woman wears a red cloak, a pearl necklace with a golden pendant and pearl earrings; her hair is styled according to the fashion of Nero's time, gathered at the nape and with a centre part. In her hands, she holds two wax tablets and a stylus, echoing the pose of another painted woman. The medallion, which was found in 1760, is one of the most famous frescoes of the Museum.

Another famous portrait is of a girl of high social standing (golden jewelry, and a hairnet according to the fashion of the times). She is shown holding four wax tablets in her left hand and a stylus in her right hand, which she brings to her lips in a pensive attitude.

✹ Pompeii And Nucera: The Game And The Brawl

This painting was taken from the peristyle of a home. It illustrates the brawl that broke out in Pompeii in 59 CE during the games between Pompeii and the nearby town of Nucera in the arena; the fight was so serious that the amphitheatre was then closed for ten years (Tacitus, Annals, XIV, 17).

As an attentive bystander, Tacitus reconstructs the events thus:

In those times, minor incidents gave rise to violent, fatal fights between the Nucerians and the Pompeiians, during a gladiator fight organized by Livineio Regolo, who had been expelled from the Senate. The fights began, with the intemperance typical of provincial cities, by exchanging insults, then stones, then by grasping swords. The Pompeiians, the hosts, won. Many Nucerians were carried back to their cities, their bodies mutilated or injured, and many mourned the deaths of their children or parents. The Prince [Nero] tasked the Senate with investigating the incidents and the Senate delegated the inquiry to the consuls. When the matter returned to the Senate, the Pompeiians were banned for ten years from organizing such events and the associations that had arisen illegally were dissolved. Livineio and the others involved in the brawl were exiled.

The centre of the composition illustrates the amphitheatre, including its stairways and the *velarium* suspended above it. inside, one may see fights on the stairs and in the arena. Some supporters are brawling, others lie on the ground, injured, while others flee, their arms flailing in the air. Next to the amphitheatre is a gymnasium with a swimming pool, while in the lower part of the fresco, one may see the street vendors' kiosks. For the sake of accuracy, it should be noted that the ten-year ban was later reduced to two years, probably thanks to the intercession of Poppea (Nero's charming wife), whose villa was nearby[28].

[28] Coltellacci. *Op. cit.* P. 273.

✸ The Reggia Di Caserta

Luigi Vanvitelli, who had worked for the Papal State, inherited his love for painting from his father, Gaspare Van Wittel. Soon, however, his passion for architecture developed and prevailed.

The genius of Luigi Vanvitelli (Naples, 1700 – Caserta, 1773) may be seen in the architecture of the imposing complex of the *Reggia*, which develops over a sprawling space and includes the great Piazza in front of the Reggia, the Royal Palace, the Park and the English Garden.

The remarkable continuity of perspective is obtained thanks to a sequence of several elements: the Charles III Boulevard, the Palace Gallery, the Park Boulevard, the great Waterfall. Vanvitelli created the Caroline Aqueduct, 41 kilometres long, to feed the Waterfall in the Park of the *Reggia di Caserta*.

His teacher was Filippo Juvarra, who had also designed the Basilica of Superga, the façade of the Royal Palace of Madrid and the Sacristy of Saint Peter's Basilica. Vanvitelli continued his studies by observing and measuring the monuments of Rome, developing a particular interest for Vitruvius.

The sovereign, Charles of Bourbon, King of the Two Sicilies, was considering a project: the military and administrative reorganization of the Kingdom. This initiative was to extend not only to building a palace that could compete with the splendor of Versailles, but also to provide the Kingdom with a new capital, far from the sea and the menaces that this could bring, as the English fleet had done when in 1742 it threatened to bomb Naples. The king intended to build a new city, in other words, of which the Palazzo Reale was to function as propulsive and administrative centre. The project was ambitious, and it was necessary to appoint an architect worthy of the task. It was from the Pope himself (Benedict XIV) that Charles of Bourbon, who would rise to the throne of Spain as Charles III, obtained the consent and authorization to hire Vanvitelli, the Neapolitan architect with Dutch origins, who was working on the preparations for the Jubilee of 1750. On 20 January 1752, the first stone

of the *Reggia* was laid. In 1773, Vanvitelli died and the work was not yet completed. This finally happened in 1843, almost 100 years after the first stone was laid, thanks to the work of his son Carlo.

The stairway of the *Reggia*, which is also known as the *Scalone d'Onore*, was an evocative backdrop to the entrance of the heads of state during the G7 summit. The stairway features a central slope that then divides into two parallel elements, with 116 steps each consisting of a single block of "lumachella" from Trapani, Sicily.

Midway across the portico, the view is of a marble background between pillars and arches, as well as the statues adorning it. There are three statues, depicting the Royal Majesty, Merit and Truth. From the stairway visitors reach the Vestibule, which is illuminated by four large windows opening onto the courtyard. The Vestibule has an octagonal floorplan, but takes on a circular dynamic in the central part, the vault over which is richly decorated. The set of pillars and columns rigorously follows the layout and geometries of the floor below it, but with an interaction of lights and colours that conceals this from all but the most attentive viewer. The splendid Palatine Chapel was reserved for the celebration of the holy rites of the royal family. The furniture in the royal apartments are striking: the great chandeliers, created by Neapolitan artisans in the 1800s, are in gilded bronze and glass; the sideboards and seats date back to the 1700s.

❀ The Park Of The Reggia

In view of its vastness, the Park of the *Reggia* provides visitors with an automotive service to allow them to travel across its 120 hectares.

Its splendor and size are clear from the very first step into the *Reggia*, when the greenery extends as far as the eye can see between the arches of the central gallery and the pillars of the courtyard. Vanvitelli insisted on the symmetrical structure, conceiving it to carry on for kilometres from the great Boulevard with which he linked Naples and the *Reggia*. King Charles'

idea of competing with Versailles allowed Vanvitelli to create without restraints: suffice it to note that to ensure the fountains' and Waterfall's water supply, the architect – relying also on the experience gained with the Aqueduct of Vermicino – had "incredibly deep wells" dug, mountains pierced, a massive viaduct 528 metres long raised by 60 metres, and the 41-kilometre long Caroline Aqueduct built. The project took 16 years to complete, but the Park finally had the volume of water required to enliven the Waterfall, the numerous Fountains and the Large Fishery. Vanvitelli however only lived long enough to see the works commenced: his son Carlo would be the one to complete the Park, albeit with some changes.

⚜ The English Garden

The marvelous English Garden of the *Reggia di Caserta* is probably one of the first English gardens to be conceived and created in Italy. It is located in the eastern side of the Park, next to the last fountain, over about 23 hectares of fertile land. The English gardener John Andrew Graefer oversaw its development. Queen Marie Caroline of Austria, the wife of Ferdinand IV of Bourbon and sister of Marie Antoinette, the wife of Louis XIV, wanted Caserta to have an "informal" or "landscape" garden, according to the fashion of the late '700s that spread all over Europe from England. Sir William Hamilton, ambassador of the British sovereign to the Kingdom of Naples, was the one to suggest the idea.

Breaking with the tradition of "Italian-style gardens", with a unitary, perspective-based and geometric composition, and introducing an English-style garden, which banished geometrical shapes and leaned towards the "natural freedom" of the greenery.

In 1786, works on the garden began and Graefer worked together with Carlo Vanvitelli to give rise to the necessary constructions and harmonize the future garden. The personal relationship between Graefer and Vanvitelli was not harmonious, but their work gave rise to a garden of rare beauty. It became not "only" a landscape garden, but also a "botanical garden", a

product of new scientific-botanical interests: many exotic and rare species were imported from exploratory travels and scientific expeditions to the New and Very New World. Graefer thus managed to synthesize fields, forests and manmade ravines in a high-impact pictorial scene, with a great deal of botanical experimentation, ranging from the capacity to grow exotic plants to the introduction of new cultivation methods.

The Park of the *Reggia di Caserta* hosts a perfect cohabitation of two cultures: an Italian-style garden, expression of the greatness of the kingdom and of the power of the Bourbon dynasty, which took its place alongside the superpowers of the time, and the English-style garden, which was intimate and spiritual. The English garden, which was less symmetrical than the Italian one, is better suited to showcasing the nature of the vegetation. The English garden extends over 30 hectares of gentle slopes, with intricate pathways leading to green spaces with cypresses, willows, magnolias, pine trees and aquatic plants. Although Graefer was often called a great botanist, he was actually a sagacious and "enlightened" agronomist: studying the soil, he placed the plants on the basis of affinity and, intuiting their adaptability, ensured their harmonious growth by managing the surrounding environment in an enlightened manner, protecting their health and taking care of them with his expertise. He applies great skill in managing the water from the Caroline aqueduct to create a network of canals to water the entire garden and thus enhance the soil's fertility; he would adapt the plants' positions to the natural slopes, to ensure that each specimen would develop in a balanced manner. Graefer's knowledge was constantly implemented in his daily work, thanks to his continuous explorations of the surroundings to "observe": his mission was to discover and understand the plants' adaptive capabilities and to learn which could be included in the garden[29]. Graefer constantly travelled around Campania, to Capri, to the Salento coast and to Palermo to maintain his stock of plants for the garden. Those that were not planted were kept in the greenhouses.

The English garden is full of native and exotic plants, including the beautiful Lebanese cedars. Also, for the first time in Europe, a Japanese

[29] Fiorenza. *Nel giardino inglese della Reggia di Caserta*. Angelo Pontecorboli editore. Florence. p. 23.

camellia (*camellia japonica*) was planted here. In 1880, Graefer managed to adapt plants from Australia and China, which may be admired in the garden to this day[30]. As noted above, the garden includes large greenhouses, a lake, a chalet and perfect replicas of ruins of ancient Roman buildings. The nearby lake hosts a life-sized statue of the goddess Venus as she is about to bathe.

Close to the entrance to the English Gardens, to the left of the ruins of the Doric temple, is the open-air classical-style theatre of Aperia, which was recently reopened for use as a venue for entertainment and culture. Walking further along the path, visitors come across a waterfall that impetuously spews froth from a manmade rock.

The long path is exceptionally beautiful, encompassing lakes, small palaces, waterfalls, streams, beautiful flowers, trees and manmade Roman ruins. Walking along it is like diving into history, mythology, botany and myriad sources of inspiration for artists that preserve their beauty to this day.

"The garden originates as the perfect equilibrium between beauty and functionality: the Bourbon Royal Sites were to be self-supporting in financial terms, such as to not impinge upon the royal finances, by producing and selling plants, seeds, bulbs, rhizomes, tubers and thaleas. Therefore, the botanist, which at the time was not yet distinct from the agronomist, called upon to oversee the composition of the gardens and agrarian arrangements, took on an important role, as a scientist or technician capable not only of finalizing the park's design, but also of improving the traditional cultivations, by testing new varieties and implants in relation with the business economic strategies"[31]. However, the botanist-agronomist must act not only as a scientist, but also as a manager: indeed, all of the botanical holdings and gardens of the Bourbon villas (Capodimonte, Carditello, Persano, Portici, San Leucio and Caserta itself) became veritable agrarian companies for the production of cultivated goods, and with sections devoted to ensuring the Court's food supply and to scientific and botanical experimentation. For example, from the starting

[30] Fiorenza. *Op. cit.* p. 53.

[31] Guarino. *Siti Reali e Disegno del paesaggio*, in Vanna Fraticelli, Naples. 1993, p. 66.

point of Caserta, new and more rational methods of agriculture spread all across Southern Italy, thanks to the experiments carried out in the *Reggia*'s orange grove, fruit orchard, asparagus gardens, strawberry fields. Thanks to this very trend, French demand for produce from Southern Italy increased throughout the 1800s[32].

Graefer's successors (Geremia, Ascione, Petagna, Tenore, Gussone and Terracciano) continued the agronomic experiments (both by introducing new species and by adopting new methods of cultivation) but focused on aesthetics, enhancing them by introducing an element of chromaticity into the garden. Indeed, the plants that produced red colours in the fall were isolated against backdrops of evergreen species, precisely to exalt their aspect and colour.

The new garden came to represent an ideal of useful beauty – of practical utility combined with aesthetic contemplation[33].

�չ The Burgh Of San Leucio: The First Socio-Industrial District

San Leucio arises on the slope of the San Leucio hill, which was once crowned by a small church devoted to Saint Leucius. Later, Ferdinand IV had an octagonal hunting chalet built upon the ruins of the chapel to hunt migratory birds. The site had already hosted hunting quarters; named Belvedere, the chalet was once surrounded by thick vegetation filled with wild animals, and belonged to the Counts of Acquaviva. When Ferdinand took over the land in 1773, he had a wall built around the area. From that year, the estate became the young king's favourite site, as it was an ideal place for him to immerse himself in the tranquility of nature and devote himself to hunting.

In 1778, King Ferdinand decided to dedicate the Belvedere area to pursuits that would be more useful for the Kingdom and for the future of the many uneducated children of the burgh. He thus turned the burgh into a

[32] Fiorenza. *Op. cit*. p. 30.
[33] Fiorenza. *Op. cit*. p. 24

manufacturing centre dedicated to the production of silk: the Royal Silk Colony of San Leucio, the only example in Europe of a factory being hosted within royal dwellings.

In the beginning, only a few subjects could live in the grounds, having the specific task of guarding the royal forests; later, the number of inhabitants grew. The king was concerned that the youth could become a "dangerous society of delinquents"[34] because of their lack of education, he established an educational house for both boys and girls. Later, to avoid the youth from being unemployed, he created a manufacturing factory of rough and processed silk. Both working and private life was governed by a sort of legal code. Indeed, King Ferdinand decided to issue regulations for the Community and for the Silk Factory, albeit "more as the education that a Father gives to his children than as the command of a Lawmaker to his subjects"[35].

He thus issued the laws of the colony of San Leucio, which began with the following words: "No man, no family, no City, no Kingdom may exist and prosper without the holy fear of God. Therefore, the chiefmost thing, which I impose upon you, is the precise observance of his most holy Law".

Therefore, upon the wish of the monarch, a Community was established which, from its very inception, was declared autonomous and independent, governed by a set of laws.

A part of the day was devoted to prayers and to attending the Mass; a part to work and, for the younger members, a part to studies.

The members of the Community could marry according to their own free will. The women had to be at least 16 years old and the men at least 20; the marriage was set out in writing and celebrated in the presence of witnesses. There was no dowry for the brides, but only a bridal trousseau, as well as a special award for spouses who had performed exceptionally in work and personal conduct.

[34] See *Origine della popolazione di S. Leucio e suoi progressi fino al giorno d'oggi colle leggi corrispondenti al buon governo di essa di Ferdinando IV Re delle Sicilie*. Naples, MDCCLXXXIX. Stamperia reale.

[35] *Ibidem*, X.

Women could receive inheritance on the same terms as men. However, marriages had to be approved by the Director of the Crafts, certifying that the couple was sufficiently skilled as to be able to support themselves. Divorce required the mutual consent of the spouses or on serious and reasonable grounds ("just cause"), which were noted in the parish matrimonial registry.

The engagement was also regulated by the law: "the parents may not become involved in the decision, but the latter should be freely made by the youths and to be confirmed as follows. On Pentecost Day, during the holy Mass, which will be attended by all members of the Community. Two youths, one of each sex, will bring to the altar for blessing two baskets of small bouquets of white roses, for men, and pink roses, for women. At the end of the Mass, each attendant must take one bouquet. Upon exiting the church, the suitors will go to the atrium, near the Baptistry, and hand their bouquet to the girl they are courting; if the girl accepts, she will give him her bouquet; but if she refuses, she will politely return his bouquet; and neither one will be allowed to object at all; and thus the first to exit the church and take up their places in the abovementioned atrium will be the Lords of the People, to impose the necessary obedience. Those who will have exchanged bouquets will wear it on their chests until the evening; when after the Holy Blessing they will be accompanied by their respective parents and go to the parish priest, who will register their name and will"[36].

The legal Code required parents to send their children to school from the age of six. Other than "reading, writing, abacus skills, religious catechism; duties to God, towards oneself, towards others, towards the Prince, towards the State; the rules of civilization, decency and discipline; teachings in all arts; home economy; good time management and everything else that is required to become an upstanding man and excellent Citizen[37]".

The site may be visited today. It still hosts the old looms and explains the production and processing of silk. The flag of the United States on display at the White House was made in the silk factories of San Leucio.

[36] *Ibidem*, XXIX.

[37] *Ibidem*, VI.

Roma: Caput Mundi Et Regina Aquarium

From a small village of shepherds on the banks of the Tiber, Rome succeeded in the effort to become the Eternal City, an international power, *caput mundi* (head of the world) of a vast, lasting empire, a unique example in history. Its way of life – the "Rome system" – is still alive in contemporary society. What made this incredible feat possible? "Romans took every precaution in three things: creating roads, building aqueducts and creating sewers" (there were innumerable drains and, given that the ancient Romans always accompanied practical sense with aesthetic taste, their covers were a lot more than mere "lids", but rather miniature works of art, usually depicting river gods). The *Bocca della Verità*, which is considered one of Rome's unmissable monuments (as in the scene from the movie "A Roman Holiday", when Gary Cooper tricks Audrey Hepburn into thinking that the statue has really eaten his mouth) was indeed one of the drain covers of the *cloaca maxima*, the largest sewer.

As the historian Strabonius wrote in the first century CE in his *Geography*, one of the winning elements of the ancient Romans was precisely their extraordinary pragmatism, united with exemplary organizational capacities and a great sense of the State. Its army enabled the enormous expansion of its boundaries; however, the formidable skill of its highly qualified engineers bolstered the Empire's stability, literally ensuring the solidity of its foundations. By disseminating the lands it conquered with infrastructure such as roads, bridges, aqueducts and sewers, as well as with forums, amphitheatres and baths, the ancient Romans spread their culture

and lifestyle throughout the Empire. And the way to plan and organize Rome became the way to plan and organize the Empire.

If creating a boundless empire required the might of an unbeatable army, to ensure its stability for so long required the greatness of an extraordinary ingenuity, a capacity to conquer and order into submission not only by means of economic and military policy – hard power – but also and especially by spreading their own culture and lifestyle, or soft power.

Rome was a *res publica* (and subsequently an empire) founded on labour, and it was on this premise that its centre, the Forum, was conceived. Half of the day, that devoted to work, or *negotium*, was to be spent here, and indeed spaces were carved out here for all activities conducive to politics, the economy, religion and social life. The other half of the day was to be devoted to leisure and physical and mental well-being; there was even room for *otium* or idleness, meaning rest from business: baths for physical health, libraries for mental health, circuses, theatre and amphitheatres for the entertainment that created a collective consciousness of the values of the *res publica*.

Interpreting the city and architectural fabric of Rome in terms of daily life illustrates the great modernity of this civilization, which had already then understood how the management of urban space is fundamental in influencing its inhabitants' quality of life[38].

Roman society was a multiracial metropolis with a solid hierarchical but dynamic structure. Indeed, servants could trade with their masters through their *peculio* (an amount of money that they had earned), and could even become free by means of the *manumission*, an actual legal institution, and thus become *liberti*, or free. The fate of a slave depended especially on his master: if the master was the emperor, a talented *liberto* could even maneuver the reins of politics, thus affecting the development of the empire. This was the case of the "Capitoline triad" of Callistus, Narcissus

[38] Coltellacci. *I segreti tecnologici degli antichi romani*. Newton Compton editori. Roma, 2016, p. 14.

and Pallante, who in the period between Caligula and Nero, throughout Claudius' reign, accumulated vast power.

The wealth and immense power of Pallante are documented in a ferocious and indignant letter written by Pliny the Young who, years later, recounts with sharp irony the honours bestowed by the Senate upon the imperial *liberto*, such as praetorial regalia, 15 million *sesterzi* and a statement of praise engraved on a bronze plaque affixed to the Forum of Caesar Pliny: he comments that "one would think that he expanded the Empire, that he returned endangered armies to the State [...]"[39].

One may also recall Petronius' story, in the Satyricon, of the great banquet offered by the *liberto* Trimalchio, whose chequerboard pieces were gold and silver coins. In addition, during the *Saturnalia* (a sort of Carnival of the times) slaves could dine at the table of their masters, or even be served by them[40].

Rome was also a city of the arts, where the wealthy were required by law to sponsor public works, and preserve and enhance the arts and culture for the benefit of the overall society, which was thus educated to enjoy beauty and grow up within it[41].

"Those who carefully consider [...] the distance travelled by water, the conducts that were built, the mountains that were pierced, the valleys overcome, will have to acknowledge that nothing as splendid has ever existed in the entire world". There are no words more appropriate than those of Pliny the Elder to introduce the subject, considering that water management is, together with the transportation network, the most significant and concrete testament to the highly skilled engineering and urban welfare talents that made Rome great. By building the aqueducts, the State ensured the provision of services that were useful to society at large, and also celebrated its greatness with veritable works of art, combining utility with beauty, in line with the pragmatic spirit that characterized the

[39] Coltellacci. *Op. cit.* p. 180.
[40] Gallico. *Guida ai Fori e al Colosseo.* ATS Italia editrice. 2000 Roma, p. 26.
[41] Coltellacci. *Op. cit.* p. 8.

civilization. Indeed, aqueducts shaped the Roman way of life, introducing the concept of the culture of water.

The construction of the first aqueduct, the Aqua Appia, took place in the 4th century BCE, when the city, which was becoming a metropolis, needed an adequate water supply, fresh water instead of that of the Tiber. The first aqueduct was then followed by many more, reaching a total of fourteen in the imperial age (this figure excludes those which were built across the Empire). An excellent practical example of the three fundamental principles of civil engineering recommended by Vitruvius – solidity, utility and aesthetics – the aqueducts met the requirement of drawing water in such a way that the flow was constant, not too fast and not too slow; therefore, its path was studied in such a way as to ensure a constant and slight inclination, overcoming all obstacles, even natural ones. The aqueducts transported enormous quantities of water: about one million cubic metres per day, an amount that was unparalleled in the ancient times and probably to this day. Indeed, it was calculated that the water supply available to Rome today is slightly greater, but its inhabitants are three times as numerous as those of the times[42]. The aqueducts changed the ancient Romans' lifestyle because they made it possible to fill the city not only with flourishing fountains – 1,352, during Trajan's times – and of luxuriant greenery, but also with public baths and restrooms that contributed to the circulation of modern ideas of personal hygiene and bodily health. The aqueducts were restored and newly built by the popes as an integral part of the project to rejuvenate the city after the Dark Ages. However, the aqueduct system was so efficient that the popes needed to do nothing more than salvage the old canals and piping systems[43].

Six of the ancient Roman aqueducts may be admired during excursions to the evocative and vast Park of the Aqueducts, within the Regional Park of the *Appia Antica*. To this day, the lifestyle followed by contemporary society is an updated version of that of the ancient Romans. Indeed, a great deal of ancient Rome endures in the world today, starting from our languages. The place where money is coined was also called *Monetam*,

[42] Coltellacci. *Op. cit.*, p. 38.
[43] Coltellacci. *Op. cit.*, p. 38.

which in Latin means "near Moneta", because in ancient Rome, it was next to the temple of Juno Moneta on the Capitol Hill. Therefore, cash began to be called "moneta", a term which migrated to English ("money"), French ("monnaie") and Spanish ("moneda"). In Latin, "moneta" means "she who warns", a qualification which was attributed to Juno when, in 390 BCE, the geese of her temple cried out and alerted the Roman population to an attack by a foreign army, thus allowing them to avert the danger[44]. Even the months of the year derive from the names given to them by the ancient Romans, and not only in Italy: January is the month of Janus, February is the month of purification (*februare* means "to purify"); March is dedicated to Mars, god of war; April is the month of Aphrodite; May to Maia, ancient goddess of fertility; June is the month of Juno; July to Julius Caesar, while August honours Augustus[45].

✣ On The Emperors' Footsteps In Rome

Termini Railway Station – Diocletian's Baths

In front of the Termini railway station stands the *calidarium* of the nearby baths complex built by the emperor Diocletian. Michelangelo converted one of the most imposing structures of the central set of the baths into the Basilica of Santa Maria degli Angeli e dei Martiri (Saint Mary of the Angels and Martyrs), thus endowing the religious building today with grandiose solemnity. The Basilica is a beautiful example of 1700s art applied onto a vast space, the original proportions of which have remained the same. This was once the largest baths establishment of imperial Rome, comprising 13 hectares of gardens, halls, swimming pools, gymnasiums, changing rooms, shops and squares immersed in luxuriant greenery. Several cubic metres of water from the Aqua Marcia aqueduct contributed to the structure's splendor, through the Aqua Iovia branch which served Rome until 1789.

[44] Coltellacci. *Op. cit.*, p. 61.
[45] Coltellacci. *Op. cit.*, p. 240.

The first proposals to transform the baths into a church were advanced by Giuliano da Sangallo and Baldassarre Peruzzi. However, it was only in 1561 that Antonio Del Duca, a priest, was able to secure Pope Pius IV's consecration of the spaces to the angels and Christian martyrs made to build the baths. Michelangelo was appointed to carry out the conversion works. At the same time, the Carthusian order (to which Pope Pius IV had entrusted the complex) built the annexed convent. The cloisters date back to 1565. Ultimately, Michelangelo's contribution was almost exclusively conservational: the *tepidarium* and the rooms which opened onto it were renovated to create a space having a floorplan resembling a Greek cross.

As for the flooring, the *Linea Clementina* crosses the space diagonally. The *Linea*, a sundial with depictions of the zodiac constellations, was designed by Francesco Bianchini and Giacomo Maraldi (1702) upon the orders of Pope Clement XI. For the Jubilee of the year 2000, the Basilica was equipped with a new monumental organ, a gift from the city of Rome to the Catholic pontiff.

✱ Piazza Navona: The Transformation Of Domitian's Stadium

Domitian built the Stadium bearing his name on what are today the grounds of Piazza Navona, in 85 CE. The structure was reserved to athletic competitions, which, together with the musical and poetic performances taking place in the nearby Odeon which he ordered to be built south of the Stadium, collectively formed the *Certamen Capitolinum*, or games in honour of Jupiter Capitolinus.

The Stadium, built on the basis of Greek models, was 275 metres long and 106 metres wide, and held about 30,000 spectators. The Stadium was renovated by Emperor Severus Alexander in 226 CE and was used up until the early 400s CE. Later, as it was progressively dismantled and its building material reused for new constructions, during the Renaissance it was replaced with a *piazza* which traced its floorplan and dimensions exactly, even preserving its curved northern end.

More specifically, Piazza Navona extends over what used to be the arena of the Stadium, and the surrounding buildings over where the spectator stands once were: the remains of the ancient Roman structures can still be seen in the basements of some of the newer constructions and of the church of Sant'Agnese in Agone. The *Fontana dei Quattro Fiumi* (Fountain of Four Rivers) which dominates the centre of the square was erected in 1651 by Gian Lorenzo Bernini and is crowned by an obelisk, a Roman imitation done during Domitian's times and which was originally in the Circus of Maxentius.

On 24 October 1648, the Church of Rome attended negotiations in the city of Münster to sign the Peace of Westphalia as a defeated party. The Peace imposed upon the Church of Rome ordered it to consider the existence of other religions, to grant these freedom, and to assign the taxes levied from many European States to other beneficiaries. The Church basically accepted the treaty, albeit very reluctantly, and sought to convey its indignation to the world the very next day. The agreements were honoured, but the Pope expressed his regret with two deeds. One was the papal bull calling for the jubilee of 1650, in which he called upon pilgrims to unite under the Catholic banners. The other official deed was a brief entitled *Zelo domus Dei*. The Fountain of Four Rivers, which had been a true star of the touristic galaxy right from its inauguration on 12 June 1651, thus became a symbol, a sign of a dramatic historical moment for the Church. In addition, as argued by the historian Cesare D'Onofrio, it became the sculpted transcription of the written message enshrined in the papal bull issued by Pope Innocent X. Therefore, the Fountain fulfilled several different functions at the same time: it was an expression of the politics adopted by the Vatican; it was a message to the world; and it was the masterpiece of "the drawing room of the Pamphilj family", or Piazza Navona. More precisely, perhaps, it was the pawn with which the Pamphilj family tried to checkmate the Barberini family, whose palace, Palazzo Barberini was a model of dynastic glorification and had been designed by the most renowned artists of the time. Before the Rio de la Plata, the Danube, the Nile (whose face is veiled because at the time, its source was unknown), the Ganges and the natural and animal world surrounding it, viewers become acquainted with all of the world's continents – with the

whole world itself. However, the world is faced with the threat of imperious paganism, which is represented by the obelisk. Redemption from this scourge is symbolized by the last element placed atop the obelisk itself – the dove of peace, which, from the height of its 170 centimetres, as a symbol of reconciliation and central element of the Pamphilj family's coat of arms, reassures viewers that religion will be capable of leading the world through the storm, and of saving it.

Symbolic language and all the splendor of Baroque monumental communication exalt one another, in a masterpiece of dazzling beauty. Beauty that does not engage the intellect directly but rather provokes it, by touching the hearts of those who behold it, forcing them to participate emotionally in every curve of marble, in every detail and, only at the end, to read its layers rationally[46].

The Roman Forum

The commercial, religious, political and judicial heart of the city throughout the republican era, the Roman Forum is closely linked to the transformation of the primitive villages built on the nearby hills into an urban collectivity.

Rectangular in shape and linked to the Palatine and Capitol Hills by the *via Sacra*, the Forum underwent continuous mutations and transformations: politicians and emperors all contributed to its constant enrichment, commissioning new buildings and renovating structures and monuments. Towards the end of the 7th century BCE, after the land was drained of stagnant water with the *Cloaca Maxima*, it was delimited and finally paved for the first time. From that moment onwards, the part of the valley under the Capitol Hill would be devoted to political functions, with the creation of the *Comitium* for popular assemblies and of the *Curia*, which was to host the Senate's sessions. The *Curia*, a majestic building which was the

[46] Beltrame: La Storia di Roma in 100 monumenti e opere d'arte. Newton Compton editori. Roma 2015.

seat of the Roman Senate, is 21 metres tall. Within it, two lateral podiums would host the 300 senators elected by the people of Rome; the senators would sit on one side or another depending on whether they voted for or against a given measure. At the far end of the space stands a porphyry statue which was recovered from the rear side of the complex, replacing a statue of the Goddess of Victory which was lost. At the sides of the hall, two large sculpted stone slabs give an interesting glimpse into life in the ancient Roman Forum, showing the Emperor writing off the debts of some citizens and the destruction of the tablets on which the debts were noted (left) and the distribution of financial aid to the poor (right)[47].

The largest part of the complex took on the role of the *piazza* (the actual forum), where among shops and marketplaces stood the oldest religious sanctuaries of the city.

A small sanctuary composed of an altar, an honorary column and a memorial stone with an inscription dating back to the 6th century BCE was interpreted as the tomb of Romulus, Rome's mythical founder. It was protected with enormous slabs of black stone (*Lapis Niger*).

The *Via Sacra* linking the Palatine Hill to the Capitol Hill crossed the entire length of the square to ascend to the Temple to Jupiter, on the Capitol Hill. Armies that had successfully concluded military campaigns would return home and march in celebratory processions held along this road.

Over the 2nd century BCE, the construction of the first basilicas – in particular, the Basilica Emilia – emphasized the nature of the Forum as centre of political and administrative life, and the complex gradually took on its final layout. The Basilica Emilia is the only survivor of the basilicas built during the republican era and served the purpose of providing visitors to the Forum with a hospitable, covered space within which, in bad weather, at least part of the functions that normally took place outdoors could be held, especially those relating to the administration of justice and the conduct of business.

[47] Gallico. *Guida ai Fori e al Colosseo*. ATS Italia editrice. 2000. Rome. P. 23.

Alongside this intricate and spontaneous life, the Forum always hosted "official" events. The seats and offices of the magistrates were all located here: the consuls and senators in the *Curia*, the tribunes for the people in the *Comitium*, the praetors in the tribunals. From the *Rostra*, the magistrates and persons running for public offices would speak to the people; inside the *Comitium*, the people elected the magistrates; and in the *Curia*, the Senate gathered for its sessions.

Religious processions and sacrifices to the gods also took place in the Forum, as did the great funerary processions that sometimes paused in front of the *Rostra*, from which an eulogy to the deceased would be spoken (of which one of the most famous is that delivered by Mark Anthony for Julius Caesar). Before the amphitheatres were built, the gladiatorial *ludi*, or games, would also be held on the *piazza*, free of charge for the general public.

One of the most famous games had been organized by Julius Caesar in 65 BCE, with 320 pairs of gladiators; just as renowned was the banquet offered by Caesar to celebrate his victory, in 45 BCE, which went on for several days and was attended by about 22,000 guests.

At the end of the republican era, it was abundantly clear that the Forum was no longer large enough to support the new operations required by the capital of an immense empire. Julius Caesar was the first person to undertake what, at the time, was understood as a simple enlargement of the old Roman Forum. Augustus, the Flaviuses and Trajan added new monumental *piazza*, to achieve a vast public complex extending from the slopes of the Quirinal Hill, where the ideological, administrative, legal and commercial activity of the city would gradually congregate.

❧ Trajan's Forum: The Emperor Who Entered Dante's Paradise

This was the last construction to be built, under the *optimus princeps* ("the best ruler") who led the Empire to its greatest expansion. For his Forum, Trajan spared no expense and appointed the star architect of the time,

Apollodorus of Damascus, a genius who managed to create this imposing public work in only five years.

At the end of the *piazza* stood the Basilica Ulpia (from the name of Trajan's family), the largest ever to be built in Rome. Then, there were two libraries – one Greek and one Roman – flanking the famous marble column. When Trajan died, a temple devoted to the deified emperor and his wife Plotina was added to the complex. Trajan completed his urban renewal, his *renovation urbis*, by extending the Appian way until Brindisi, today in Southern Italy; building a grandiose port and fabulous baths at Fiumicino; expanding the Circus Maximus and the Cloaca Maxima; extending the water network not only in Rome but also in Dalmatia (today, Croatia), in Spain (his native land) and in the eastern part of the Empire – that is, where the dry climate required a greater water supply; reinforcing the Tiber's banks; and in Egypt, connecting the Nile to the Red Sea by means of a great channel (the Trajan River).

However, Trajan did not focus his efforts and those of the Empire on military campaigns and public constructions alone. He was also a prudent statist and a philanthropist, who took great interest in the living conditions of his citizens and was therefore an attentive social and political reformer. Indeed, in the judicial context, Trajan cut trial times, banned the possibility to accuse individuals anonymously, agreed to allowing retrials in case of *in absentia* convictions and prohibited convictions without solid proof or in the presence of any doubts. In the economic and social spheres, Trajan managed to streamline the bureaucracy and approved legislation supporting small farming landowners, whose livelihoods were under threat due to the expansion of large estates. He also order the burning of the registries of back taxes (as depicted in the *plutei* of the *Curia* building) to lighten the fiscal burden upon the provinces, and abolished some taxes levied on the provincial and Italic populations. In this way, he was able to create a sort of popular savings and loans bank that granted loans to small-scale farmers and Roman entrepreneurs, who could thus benefit from generous concessions. Also, Trajan issued measures to foster the first cooperatives and trades guilds.

However, as mentioned above, Trajan was first and foremost a great philanthropist and protector of the youth of Rome. To alleviate the poverty afflicting the lower classes of society and try to improve the declining Italic economy, he created the *Institutio Alimentaria*: using a part of his personal fortune, he was thus able to ensure nutrition to hundreds of poor children and youth. In the town of Benevento, today in the Campania region of Italy, the Arch of Trajan portrays the distribution of food to the population and especially to poor children, pursuant to the *Institutio Alimentaria*. Some bas-reliefs with the same subject may also be seen in the Roman Forum, specifically illustrating the institution of the *Alimenta Italiae* for the *pueri et puellae alimentari*.

Responding to a query by Pliny the Younger, then the young Governor of the territory of Bithynia, on the issue of Christianity, Trajan's official answer would constitute guidance for almost 140 years: he did not suggest a "rigid general rule", nor an active hunt for Christians, but rather, should they be denounced to the authorities, they were to be convicted only if they refused to pray to the Roman divinities. Anonymous reports were to be rejected.

Trajan was a truly extraordinary emperor, beloved by all – the Senate, the population, the military forces. Even someone as strict as Dante Alighieri admired his humility and sense of justice, and placed him in the Paradise of his Divine Comedy, among the just souls of the XX *canto*. Trajan was an exceptional emperor who displayed moderation and wisdom; he was also a brave military leader who knew how to reconcile *humanitas* and *auctoritas*.

An Invitation To The Imperial Domus

Nero's Domus Aurea And The Coenatio Rotunda

The *Domus Aurea* covered 250 hectares: therefore, it was neither a villa nor a palace, but a veritable neighbourhood, an articulated complex of large buildings with long porticos and halls with immense ceilings, all decorated with precious stones, stuccoes and frescoes.

Among the most famous spaces is the *coenatio rotunda*, which rotated constantly, day and night, imitating the Earth's rotation, thanks to a hydraulic system that was probably powered by a watermill. The *coenatio* was probably about 16 metres in diameter[48]. In his *Lives of the Twelve Caesars*, Suetonius writes: "The main banquet hall was circular and constantly revolved day and night, like the heavens." A sort of tower stood over the valley of the Colosseum – where an artificial lake was nestled at the time – thereby affording a 360° view of the city from the Capitol to the Aventine, from the Caelian to the Velian Hills.

Nero dwelled in his *Domus* as would a god-ruler, half-Apollo half-emperor. His lifestyle was redolent of Oriental traditions and those fineries indicative of the prosperity reached by his society in those years, during a period of the city's history by which the visions of Augustus perhaps hardly made sense anymore. The emperor's splendid quarters, therefore, were something akin to the "guilty conscience" of Roman civilization – which may explain the fury with which it dismantled and buried[49].

The three hundred rooms of the *Domus* were centred upon an octagonal courtyard which was covered by a dome – one of the few surviving structures, and fortunately so: careful observers may note that Brunelleschi's dome in Florence was built using similar cunning. Indeed, Brunelleschi's desire to build grand constructions was inspire by his trip to Rome in the early 1400s, undertaken with his friend Donatello to study the ancient ruins.

The *Domus Aurea* is at once an extravagant hall for receptions, a suburban villa and – subtly, but not very much so – a temple devoted to the cult of the Emperor, a private forum. This made it an exemplified violation of all sacred principles of the Roman civilization. When Vespasian, of the *gens* Flavia, took power, he gained control over what was the very symbol of all that he wished to erase, to draw Rome back to its usual (Augustan) moral values; the Colosseum – a public and, to a certain extent, democratic

[48] http://www.beniculturali.it/mibac/export/MiBAC/sitoMiBAC/Contenuti/Ministero/UfficioStampa/ComunicatiStampa/visualizza asset.html 854392074. html.

[49] Beltrame. *Op. cit.*, p. 77.

structure – built on what was the lake of the *Domus Aurea* testifies to this intent[50].

However, a small part of the imperial villa endured throughout the ages, in the shadows, exerting irresistible influence upon artists who were to become illustrious. This is the part of the *Domus* beheld by the likes of the Ghirlandaio, Domenichino, Raphael, Michelangelo. They asked to be lowered into the surviving halls, which still bear their signatures, to copy the ancient frescoes. Those "stolen" decorations would then go on to adorn papal villas, churches, the palaces of aristocratic arts patrons. The frescoes had been originally painted by the artist Fabullus, whose artistic style that was strongly influenced by theatre scenography. The series of scenes was called "grotesques", from the very fact that at the time, the *Domus* was considered a grouping of grottoes, or caves.

The Houses Of Augustus And Livia

We can only imagine the luxury, magnificence and grandiosity of the imperial palaces, perhaps with some effort, and by strolling through what remains of that dream, where everything began: the Palatine Hill. This hill hosted the first and most "modest" imperial residence, which was nevertheless the Palace of Augustus (63 BCE – 14 CE). The city which Octavian had taken over in 23 CE was made of bricks; but by the time he died, it was definitely made of marble. The day after the Ides of March 44 BCE, which closed with Caesar's bloodied body on the floor of Pompey's *Curia*, the young Octavian learned about the death of his uncle while he was in Epirus, fighting against the Parthians on behalf of his illustrious relative. There, in the military camp, he also found out that he had been adopted by Caesar shortly before he was stabbed to death, and to have gained charge of the three hundred *sesterzi* that his uncle had left to each Roman citizen[51]. Thus, at the age of nineteen, and despite slightly poorly

[50] Beltrame. *Op. cit.*, p. 73.
[51] Beltrame. *La storia di Roma in 100 monumenti e opere d'arte*. Newton Compton editori. Rome. 2015. p. 43.

health and little military vocation, he would bring about a rebirth of the city of Rome. He would draw it out of the mires of the civil wars caused by the slow death of the republic. Although Octavian did not know how to fight, he knew how to organize a war, all the while forging alliances within and outside his party. Later on, he would learn to manage proscriptions and the other tribunes and, finally, having eliminated all of his adversaries, reform the city and assume the name of Augustus. In 18 BCE, along with the new *Leges Iuliae* (the body of legislation passed by the *gens* Iulia, starting from Julius Caesar) which regulated the subjects of divorce and adultery, new sumptuary laws, which governed displays of wealth. Thus, his city would be rebuilt in marble; Rome would become Rome; and peace would be achieved under the auspices of Octavian Augustus, whose name would never be forgotten. This, in extreme summary, is the outcome of the advent of the first *princeps* in the history of Rome[52]. The parts of the House of Augustus that are publicly accessible are particularly impressive for their decorations, their elegant, vividly coloured frescoes, and its fantasy and *trompe l'oeil* ornamentations. Inside the *domus*, cubicles with low ceilings and simply mosaicked floorings distinguish the private apartments from the official rooms, which have lofty ceilings and floors decorated with multicoloured marbles. Other than the spaces which once probably hosted the libraries and the *tablinum*, especially striking are the Room of the Masks, the Room of the Pines, and the Room of Perspectives, because of the powerfulness of the visual impact of the painted architectural structures, bucolic scenes and perspective illusions. Also worthy of note is Augustus's study room.

The House of Livia (58 BCE – 29 CE) is famous for its extraordinary wall paintings, dating back to 30 BCE. The *triclinium* is decorated with paintings that imitate windows opening onto landscapes; the *tablinium* hosts frames in the Pompeiian style depicting mythological scenes; along the left-hand walls, water pipes bearing the inscription "Iulia Augusta" may be seen, from which the attribution of the *domus* to Augustus's wife.

The Villa of Livia at Prima Porta (on the outskirts of Rome) is a precious example of garden painting. It contains an amazing painting of a fictitious

[52] Beltrame. *Op. cit.* p. 44.

garden, wild and luxuriant. Against an almost nebulous background, firs, pines, oaks, cypresses, and pomegranate trees are painted, while roses, poppies, daisies, chrysanthemums, violets and irises rise up, giving pops of colour. Birds, paths and fences are scattered over the field. The illusion of being in an open space breaks down the walls of the room, and nature surrounds viewers, immersing them in a dimension of utter peace. The frescoes once decorating the walls of the villa were removed and reconstructed in a room of the National Roman Museum in Palazzo Massimo alle Terme, where they have been revived to create an almost surreal, tranquil atmosphere. They were laid here as if to recreate the same ambience which greeted the guests of Empress Livia. The garden does not only display itself; it speaks. The laurel bushes are indissolubly linked to imperial authority. They inform us that we are not guests of just any *domus*, but rather of the home of Augustus, who saw his marriage in political terms. In other words, he and Livia were the daily embodiment of the ideals of morality, severity and justice, thus influencing the entire city. Through this decoration, the astute "first lady" exalted the message of peace, or *pax*, promoted by her husband even in the privacy of her home, thus giving rise to an emblematic unity with the motif decorating the frieze of the *Ara Pacis*: triumphantly luxurious vegetation which comprises about ninety species of trees, plants and flowers, as well as animals half-hidden in the greenery that symbolize the rebirth fostered by the *princeps*, Augustus.

Among the tranquil community that takes part in the imperial banquets, the message is clear, albeit alluded to delicately: in exchange for obedience to the *princeps*, nature prospers and bears fruit. In the Villa of Livia, beholding the masterly brushstrokes that decorated her walls, visitors witness the emotion of deep loyalty to that vision. Although the garden of the Empress is not real, the scenes on the villa's walls is truly alive, exists, is full of movement. This is because of the ideals which gave rise to it and the lives unfolding within these walls immersed in the fields and the sky, where guests are hosted by Livia, her husband's politics and the entire *gens* Iulia[53].

[53] Beltrame. *Op. cit.*, p. 49.

✳ The Colosseum

· ·

The Colosseum is the largest and most famous amphitheatre of the Roman world. It takes its current name from a colossal gilded-bronze statue of Nero, about 32 metres tall, made by the Greek sculptor Zenodorus, which once stood on the site (on the space currently occupied by a plot of land with trees, across the road from the subway station).

Construction of the Colosseum began in 72 CE under Emperor Vespasian (who ruled from 69 CE to 79 CE). According to tradition, he intended to build a large entertainment arena on the location where his predecessor, Nero, had an artificial lake built to decorate his luxurious *Domus Aurea*. It was later Titus (79 CE to 81 CE) who finalized works on the Colosseum and opened it to the public in the year 80 CE. Suetonius (70 CE – 140 CE) wrote that "after inaugurating the amphitheatre, he ordered shows to be held for 100 days, where 9,000 animals and 10,000 prisoners were killed. He presented a sham sea-fight too, and in only one day, 5,000 wild animals of every type were killed (The Lives of the Twelve Caesars – Titus, Ch. VII).

The Colosseum is oval in shape. It has been calculated that it could host up to 50,000 spectators, who could watch gladiator fights and animal hunts – the so-called *venationes*, with bears, lions and tigers. Although there were many wolves in Italy and Europe, they held a somewhat sacred status for Romans (according to legend, Romulus and Remus, the founders of Rome, had been saved by a she-wolf) and so could not be used.

The *cavea*, or seating section, was divided horizontally into five sections: the first four had marble stairs upon which spectators would sit by social status: men (closest to the arena sat the senators, followed by knights and plebeians) and, in the fifth tier, which was built in wood and tucked under a portico, sat the women. The numbered gates, called *vomitoria*, allowed for the rapid entrance and exit of viewers. The galleries and corridors, which were sheltered by vaults and crossings, were decorated with stuccoes and frescoes. The shows were free of charge and open to all social classes, paid for by the emperors until the 5th century CE. In 438 CE, gladiator

games were banned because of their ferocity; in 523 CE, under Emperor Theoderic, all games were definitively prohibited[54]. Today, the Colosseum hosts the Pope's yearly *Via Crucis*, the ceremony held every Easter to commemorate Christ's Passion.

Living Like A Prince In Rome

Villa Torlonia

Prince Giovanni Torlonia (1754-1829) was of French origins but had been living in Rome from the 1750s; here, he had managed an astounding economic and social ascent thanks to the profits from a bank opened in 1782. Between 1802 and 1806, he commissioned Giuseppe Valadier, renowned architect of the time, to expand the family villa on Via Nomentana (in the northern part of Rome, acquired in 1797 from the aristocratic Colonna family), adding avant-corps, porticoes and spacious terraces. Upon Giovanni's death (in 1829), his son Alessandro commissioned the architect and painter Giovan Battista Caretti to adorn and enlarge the building: he introduced the side porticoes and Palladian vestibule. Many painters, among whom Francesco Podesti and Francesco Coghetti, contributed to decorating the rooms, together with sculptors and stucco artists from the school of Bertel Thorvaldsen and Pietro Tenerani. When the villa was rented to Benito Mussolini between 1925 and 1943, the basement was converted into a bomb shelter and bunker; these have been restored and may be visited today upon advance booking. After the restoration works completed in 2006, the building's two reception floors host the Villa's Museum, which displays works from the immensely rich statue collection of the Torlonia family and antique furniture. A short distance from the *Casino Nobile*, or Palace, to which it is also linked by means of an underground tunnel, stands the *Casino dei Principi*, a small building that was also transformed and expanded first by Valadier and later by Caretti.

[54] Gallico. *Op. cit.* p. 52.

Quintiliano Raimondi (1794-1848) also designed the beautiful Theatre and *Limonaia*, or lemon orchard. The Theatre was constructed in celebration of the marriage between Alessandro Torlonia and Teresa Colonna in 1840. Both the architecture and the decorative themes commemorate the subject of the couple. This is one of the most interesting examples of Italian 1800s theatre architecture: indeed, Raimondi expertly and wisely combined several architectural styles, according to the eclectic tastes of the time. The central body of the structure echoes the solemn and classical grandiosity of the Pantheon; its southern side, however, with its reliance upon glass and cast iron, is of clearly Nordic, innovative, inspiration. The main façade to the south features a large semicircular colonnade, which is enclosed by large windows and rests upon an original greenhouse built in glass and cast iron. Through the two side apartments, visitors may access the theatre room, which is horseshoe-shaped and presents two tiers of stages. The backdrop to the stage may be opened up, allowing for a view of the park during daytime shows.

The spaces are all decorated with tempera and oil paintings, stucco friezes, stucco and marble statues and mosaic floors. Most of the paintings were done by Costantino Brumidi, little known in Italy but renowned in the United States for having painted most of the Capitolium in Washington, D.C.

However, the theatre was rarely used: only one newsworthy event has come down to us, about a play organized in May 1905 by the young Prince Giovanni Torlonia junior titled "The Profile of Agrippina". After the play, over 500 people were welcomed to the apartments and the society pages of the time all reported details on the event. After that, however, the Theatre slid into a slow decline which led, in only a few years, to its degradation. It was reopened only in 2013, after a lengthy and attentive restoration that brought it back to its former splendor. The Theatre is now a museum and hosts theatre and musical performances.

As Caretti's works were being carried out, in the southern part of the park, Giuseppe Jappelli created an English garden in which nestled the *Casina delle civette*, or House of Owls. As mentioned above, from 1925 to 1943, the Villa was rented to Benito Mussolini and his family, for the symbolic

amount of one *lira* per year. During this time, Prince Giovanni Torlonia junior lived in the *Casina delle civette*.

In the complex of buildings that may be viewed today in the park of Villa Torlonia, the *Casina delle civette* stands out for its whimsicality. The structure was first built in 1840, when Giuseppe Jappelli, a renowned landscape architect from the Veneto region (in the north of Italy), designed a rustic-looking "Swiss cottage", to be built with rough blocks of stone and wooden beams, imitating a mountain chalet or hermit retreat. The current appearance of the building results from two successive transformatory interventions, one dating back to 1910 and another occurring between 1917 and 1920. Both were commissioned by Prince Giovanni Torlonia junior, the grandson of Alessandro, who had decided to transform the *Casina* into his residence according to the fashion of the time, leaving the luxurious Palace.

Little is known about the personality of "don" Giovanni. At the time, he was known for his sullenness and misanthropy and his motto, "*Sapienza e Solitudine*", or Knowledge and Solitude, stands proudly to this day, sculpted into the architrave over the main door, conveying his ideals. During the first stage of renovations, the building was enriched with a new wing, porticoes and jagged attic rooms, while the attached cottage was converted into a residence for the help. Thus, the complex took on the appearance and moniker of "Medieval Village". However, as soon as 1917, the young but already famous architect Vincenzo Fasolo began to add Art Nouveau features, with a panoply of turrets, bow windows, arches, balconies and porticoes.

Given its inclusion of different architectural styles, the *Casina* assumed an eclectic nature, unique especially because its myriad decorative elements combined with one another in an interesting harmony. The entire building was decorated with cast-iron ornaments, woodwork, mosaics, ceramics, wall paintings, stuccoes, inlaid marbles and especially stained glass panels, featuring the recurrent theme of the owl (*civetta*), from which the name *Casina delle Civette*. Indeed, its characteristic stained glass windows are so

numerous that, upon completion of the renovation works, it was ultimately converted into the *Museo della Vetrata*, or Museum of Stained Glass.

✸ Palazzo Colonna

In the heart of Rome, between Piazza dei Santissimi Apostoli, Via Quattro Novembre and Via della Pilotta, extends the imposing Palazzo Colonna, a Roman Baroque palace whose simple exterior belies regal treasures within.

The decorations of the Galleria Colonna include, indeed, majestic Corinthian columns, rare marbles, classical statues, monumental wall panels in sculpted, inlaid and gilded wood, precious tapestries and mirrors decorated with flowers and cherubs. The cherubs were created by Carlo Maratta, while the flowers are the work of Mario de' Fiori, a painter whose subject was, exclusively, precisely flowers. The ratio between the space's length (39 metres), width (10.5 metres) and height (13 metres) conveys a sense of harmony. Light floods in through twenty windows, ten on each side, and the two ample doorways. The hall's two consoles are also worthy of note, especially that made of ivory into which classical and Christian scenes have been carved.

The Colonna family's illustrious ancestors include a pope: Pope Martin V (born Ottone Colonna in Genazzano, near Rome, in 1368; deceased in Rome on 20 February 1431). Upon assuming power, Martin V realized that the city was full of neglected buildings, including the papal residence, Palazzo Lateranense. He was a patron of the arts during the dawn of the Renaissance. However, at first he chose to live in Palazzo Colonna, which thus became papal seat for some time. His portrait is displayed under the red velvet canopy in the room which, as was the custom of the major aristocratic families of the time, was dedicated to the sole purpose of hosting the popes' yearly visits.

The Galleria also celebrates the deeds of the members of the Colonna family, especially those of Marcantonio II Colonna, hero of the Battle

of Lepanto. The fresco painted in the first room in 1700, by Giuseppe Bartolomeo Chiari, a disciple of Carlo Maratta, depicts the leader as a "new Hercules", being presented to a female figure representing Eternity.

Among the most famous frescoes of the Galleria Colonna is an exquisite Madonna, painted by Bronzino, and the *Mangiafagioli*, or Bean Eater, by Annibale Carracci (1560-1609). The *Mangiafagioli* indeed portrays a farmer eating beans, who stares back at viewers as if they are interrupting him. This fresco was highly innovative at the time, and would anticipate Caravaggio's realistic style.

Pompeo Batoni was the creator of two splendid Renaissance allegories: in "Time discovering Truth", a beautiful young girl, Truth, displays a light whose rays illuminate the entire room, while on the right-hand side, Time unveils her and to the bottom Deception, a disturbing, blinded figure, flees. The symbolism is obvious: Time reveals Truth, which chases Deception away.

The Galleria Colonna was also the setting for the final scene of the movie "Roman Holidays": you might hear the journalist Joe Bradley's steps echo through the hall, as he, the only one left in the press conference, slowly walks away.

The apartments of Palazzo Colonna are also interesting to visit. The artists who adorned its halls include Pinturicchio, Cosmé Tura, Brueghel, Patinir, Bril, Dughet, Vanvitelli. Don Marcantonio Colonna lived in these apartments for most of the 20th century with his wife, Isabella Colonna. Isabella, of Lebanese origins, devoted much of her long life to renovating Palazzo Colonna. During World War II, having heard that the German troops were approaching, she preserved many works of art by walling them into the Palazzo's walls.

The first thing visitors see is a series of family portraits, including those of Marcantonio I, leader of Pope Julius II's guard, Marcantonio II, leader of the papal fleet during the Battle of Lepanto (1571), Maria Mancini Mazzarino, the wife of Lorenzo Onofrio Colonna and niece of the famous

Cardinal Mazzarino. We will now explore the exceptional history of this Roman noblewoman.

Already from the early 1500s, the palace belonging to the Mancini, an old Roman family, stood on Via del Corso. Its family chapels were on the Ara Coeli and in the Basilica of the Holy Apostles, a few steps away. In 1600, the palace experienced a sudden outburst of cultural life, which culminated with the establishment of the *Accademia degli Umoristi*, a small community of artists and intellectuals, including famous writers such as Marino and Tassoni, who would gather periodically in the hall on the ground floor; there, they would hold literary discussions in which gentlemen and poets alike would improvise motets and short encomiums or elegies.

In 1634, Geronima Mazzarino, the sister of Cardinal Mazzarino, married Lorenzo Mancini. After the latter died, the fortunes of the Roman family largely depended upon the fate of the Cardinal, who in addition to being Geronima's tutor, was also the Prime Minister of King Louis XIV. In 1653, Geronima visited her brother in France with her daughters Ortensia, Maria, Vittoria and Olimpia. They were the famous "*mazzarinette*", who went down in history for their uniquely Italian charm imbued with an unusual sense of adventure and independence.

In Maria Mancini's memoirs, written in response to disputes that had arisen regarding their birth, she states: "I was born in Rome into a noble and illustrious family, and if it had not been for my uncle's fortune, which is known to all, we would nevertheless have enjoyed a prominent position in the most important city in the world".

Maria Mancini was born in 1639 and, as mentioned above, went to Paris after the death of her father, when she was thirteen years old. As she writes in her memoirs, she was neither pretty nor particularly beloved by her parents. However, she was intelligent, spirited and daring, and charmed Louis XIV with displays of sincere affection. She and the young Louis XIV began an intense friendship which soon became a stable romantic relationship.

It was the first romantic experience for both of them, and Mademoiselle Mancini, who ran the shows, turned to literature for help. Together, the young couple read the *Astrée*, the great pastoral novel that praised Platonic love and taught chivalry and respect for the gentler sex. Both elected, as role models, the heroes of the novels of Mademoiselle de Scudéry, embracing the precious utopia of a world governed only by the laws of chivalry. Their dreams were those of their age and their times, and, as Louis XIV was a king, nobody better than he could embody this illusion. Thus, for six blissful months, with parties, dances, walks, concerts, absorbed in their love, the two youths lived in perfect happiness to the astonishment of the entire court. Perhaps, onlookers thought, life could really be like a novel.

However, both Cardinal Mazzarino and Anna of Austria, the mother of Louis XIV, opposed the marriage for reasons of political opportunity. Indeed, they sought to conclude the Treaty of the Pyrenees, to finally reestablish peace between France and Spain. Therefore, they encouraged the Sun King to marry Princess Maria Teresa, the daughter of Philip IV of Spain; from this union, six children would be born. The scene of the dramatic farewell between Louis XIV and Maria Mancini inspired the French playwright Racine to write a scene of his play *Bérénice*. Maria was instead to marry Lorenzo Onofrio Colonna, Viceroy of Aragon. Used to life in France, Maria had three theatres built inside Palazzo Colonna, and also organized many costume balls, as was custom in France. Although Maria's return to Rome was initially triumphant, her relationship with her husband, which produced three children, turned sour, to the point that she ran away from Rome in 1672 to set sail for France. Thus she began a vagrant and solitary life that would lead her across Europe.

In one of the rooms of the Colonna apartments, there is an ancient nocturnal clock which, still working, portrays Maria Mancini and her sisters being ferried across the Styx by Caron. In the modest inventory written up at Pisa, upon her death, Maria had always jealously guarded two things: the necklace of 35 pearls, once belonging to the Queen of England, that Louis XIV gifted to her upon parting, and the magnificent diamond ring that her husband had given to her on their wedding day.

Maria Mancini asked to be buried where she would die. And she died in Pisa, on 8 May 1715. Her tomb is very simple, as she requested herself. The inscription thereupon states: "Maria Mancini Colonna, pulvis et cinis" (Maria Mancini Colonna, dust and ashes). A few months later, Louis XIV would also die, on 1st September 1715. A nephew would survive him.

In the Colonna apartments, a room with frescoes by Giacinto Gimignani celebrates the wedding between Maria Mancini and Lorenzo Onofrio Colonna, which took place in 1661. In the frescoes, one may see the families' two coats of arms: a column and a pair of fish. the ceiling of the room also celebrates the union, depicting in one corner the two fish symbolizing the Mancini family as a zodiac sign, and in another the Colonna's column crowned by Glory; in yet another corner, Love is portrayed. In 1663, for the birth of their first son, Philip II, the artist Schor created a parade bed made of a floating shell. However, this was later dismantled because of its excessive size; all that remains is a trace in a console preserved in the Palace. In the room, visitors may also see the inlaid, gilded cradle of the young prince, shaped like a ship.

Palazzo Colonna also hosts some interesting frescoes painted by Luigi Vanvitelli, depicting the nearby Piazza del Popolo when the slope up to the Pincio park, of Villa Borghese, had not yet been built. Another fresco by Vanvitelli shows Villa Medici before the Trinità dei Monti steps were constructed upon commission of Pope Clement VII in 1717; yet another portrays Trinità dei Monti when there were still shrubs instead of the famous steps.

✸ Galleria Doria Pamphilj

The Galleria's "birth certificate" dates back to 1651, when Pope Innocent X indissolubly ties the properties to the institution of primogeniture, prohibiting their separation and sale.

The Galleria assumed its current appearance between 1731 and 1734, when Prince Camillo Pamphilj junior commissioned Gabriele Valvassori works to adjust the Palace's oldest structure, which stood on Via del Corso, already then one of the city's most important roads and an obligatory part of the route of processions, celebrations and parades to celebrate ambassadors to the papacy. The Palazzo's new façade was unveiled on 1st July 1734. Previously, Valvassori had closed the loggia overlooking the courtyard, whose construction dated back to the 1500s, thus creating the "quadrilateral-shaped" Galleria. Three long arms hosted the collection's artworks; that overlooking Via del Corso, instead, was made into a Gallery of Mirrors. Recently, the artwork was rearranged according to their original placement, which was recorded in a manuscript of 1767 preserved in the Doria Pamphilj archives. The Gallery of Mirrors is part of the exhibition spaces designed by Valvassori starting from 1731; the current layout alternates gilt-framed mirrors with ancient statues.

Giovanni Battista Pamphilj, who was elected Pope in 1644 as Innocent X, was the Pope who commissioned the Fountain of the Four Rivers, in Piazza Navona, from Gian Lorenzo Bernini. The Galleria Doria Pamphilj also holds a portrait of the famous pope, done by Velazquez.

One of the most interesting paintings in the Galleria is the Rest on the Flight into Egypt of Caravaggio (1571-1610). Caravaggio depicts the Holy Family's long journey to Egypt to flee from Herod the Great's ploy which culminates, tragically, in the Massacre of the Innocents in Bethlehem. The illustrious painter bases his interpretation on Matthew 2:13, which tells about Joseph's dream in which an angel sent by God tells him to rise, take his child and wife and escape to Egypt, because King Herod wanted to kill baby Jesus. Long before then, the prophet Isaiah had already foretold that Jesus would descend into Egypt: See, the Lord rides on a swift cloud and is coming to Egypt (Isaiah 19:1).

We may thus see Mary – asleep, her head leaning forward – while holding the Holy Infant as the ethereal cloud that wraps around the Lord, the tabernacle who holds him and protects him during the journey to Egypt, swaddling him with maternal love and infinite tenderness. Joseph is portrayed holding

a musical score for a violin-playing angel. Although exhausted (as we may tell from his weary face), he watches over his resting spouse and infant Jesus, with great paternal love, does his part to lull his child to sleep. In the scene, the angel separates Joseph from Mary to show that the husband is at the service of the wife, and she can never be his possession.

Indeed, this is a very original representation of the Biblical scene. First and foremost, the figure of the angel turns away from the viewer, is robed in white cloth and intently plays the violin. The musical score is not a random mass of notes: rather, it is the actual score of a motet by the Flemish composer Noel Bauldwijn. The words are drawn from the Bible's Song of Songs and are devoted to the Virgin Mary, starting with *Quam pulchra est*, or "How beautiful you are". At the far left corner, the lifelikeness of the cord-wrapped flask stopped with a rag exemplifies the painter's aptitude for still life. To the right of the angel rest the Virgin Mary and the Holy Infant, surrounded by luxuriant vegetation. Both are depicted in an idealized style and the beauty of their facial features contrast with the realistic portrayal of Saint Joseph.

The Rest on the Flight into Egypt is the first large-size Biblical painting done by the young Caravaggio, dating back to about 1596.

Next to this work is another painting by Caravaggio, the Penitent Magdalene. Comparing the two canvases, viewers may note that the same model was used for both female figures – Maddalena (known as Lena) Antognetti. After all, she was Caravaggio's favourite model (and perhaps also partner)[55].

In the painting, Magdalene is seated on a chair, crying disconsolately. To the left-hand corner, a small jar of ointment, a pearl necklace and some jewels are placed on the ground, symbols of the world's vanities. Magdalene is shown at full length, alone at the centre of a bare room. Daylight streams in through a window up high, which cannot be seen. In this way, although not directly addressing the viewer, the woman fully conveys her pained and silent meditation on sin and penitence.

[55] Beltrame. *Op. cit.* p. 340.

✸ Palazzo Barberini

This Renaissance palace was built atop a hill, such that its large bulk (although almost lost to contemporary viewers, given the newer buildings crowding around it over the years), standing imposingly over the surrounding lands, must have aroused much admiration. Indeed, the Barberini Palace was not only the residence of the Pope's family, but soon turned into a "temple" of Baroque culture and of its expression through architecture, painting and sculpture. In other words, in this palace, which from 1949 also holds part of the collection of the National Museum of Ancient Art, you will find much more than a "simple" ode to power. You will find a "snapshot" of the times, of the musings of the intellectuals of an age that was extremely rich in cultural references, which have gone lost over the years and are incomprehensible to us now. Also, in architectural terms, Palazzo Barberini was a centre that drew upon the best minds of the time: Carlo Maderno, who designed the building's basic structure; Bernini, who introduced the Baroque element, also enlisting the work of Borromini, who built the helix-shaped staircase. From 1633, Pietro da Cortona worked on the grand decorative elements, painting, in the residence's *Salone*, the main reception hall, one of the most significant and emblematic frescoes of Baroque painting: the Triumph of Divine Providence, which due to its wealth of symbols and allegories could very well be a sort of "domestic Sistine Chapel" depicting Roman society during the times of Pope Urban VIII. Pope Urban, whose birth name was Maffeo Barberini, was one of the most refined, erudite and intelligent patron of the arts of his day. For the Barberini family, its leader – the Pope – was the right man to materialize the civilized ideals of wisdom, strength and justice that the world had been waiting for. Therefore, it was only fair for his residence to celebrate his deeds and character in a style that would make the history of Roman Baroque.

The Triumph of Divine Providence covers an area of over 400 square metres. Its figures interact and dialogue with one another, culminating in the central scene (the fresco is divided into five zones: four side panels and one central one).

At the centre of the ceiling is the Divine Providence, wielding a scepter and surrounded by a luminous halo which alludes to its divine emanation. Behind it are seated Justice, Piety, Power, Truth, Beauty and Modesty. Above them, the three theological virtues (Faith, Hope and Charity) hold a laurel crown whose shape echoes a coat of arms, and into which fly three bees, the symbol of the Barberini family. Other personifications in the fresco are the Goddess Rome with the *Triregnum* (an allusion to the papacy) and Glory, holding the Keys of Saint Peter. A further reference to the pope in power is the cherub which, in a corner, holds out a laurel crown, as if to crown Maffeo Barberini's poetic talent. The four side panels allude to "good government" under the Barberini family, illustrating deeds done by the Pope and his nephews. The first panel shows Peace enthroned being advised by Prudence, who sends a young girl to close the gates of the temple of Janus (which in Ancient Rome were kept open during wartime). Cyclops toil in workshops to make weapons, while Fury is disarmed by Docility and is forced to stand still on a pile of weapons. On the opposite side is the Triumph of Religion and Spirituality, with Science looking heavenwards, next to Divine Succour, Religion and Purity. The back wall depicts the fall of the Giants, over which soars Minerva, to symbolize the victory of intelligence over brute force. On the window walls, Hercules drives away Vices and Harpies, which represent greed. A young girl with the consul's band alludes to Justice, while Liberality floods the world with coins, flowers and fruit from her cornucopia.

Maffeo Barberini was elected Pople on 5 August 1623. Already as a cardinal, Maffeo Barberini became known for his love of the arts and his patronage, which he directed not only to the figurative arts but also to the Roman literary scene of the time, in which he played an active part as poet. His pontificate lasted 21 years and was a time of great artistic splendor.

The ceiling painted by Andrea Sacchi (1599-1661), representing Divine Wisdom, is stunning. It was commissioned by Prince Taddeo Barberini. The Allegory represents Divine Wisdom, which is portrayed at the centre of the composition as a woman sitting on a throne; in her right hand, she holds a scepter with the Eye of God, while in her left, she holds a mirror symbolizing Prudence. On her breast appears a small sun, a symbol of the

Barberini family, along with the bees decorating the throne. The woman is surrounded by 11 female figures, which represent her virtues. From left: Nobility with Ariadne's Crown, Justice with her scales, Strength wielding a club, Eternity with a serpent, Sweetness holding a lyre, Divinity with a triangle, and Beneficence with an ear of wheat. From right: Beauty with Berenice's Hair, Perspicacity with the eagle, Purity with a swan and Holiness with a cross and altar. In the sky, two winged archers appear: the archer astride a lion represents God's love, while the one on the hare represents the fear of God. The enormous globe appears to rotate around the sun painted behind the throne, as if Sacchi were aware of the recent heliocentric theories espoused by Galileo Galilei and Nicolaus Copernicus.

The stars painted on the virtues correspond to the astral configuration of the skies on the night of 5 August 1623, when Maffeo Barberini was elected Pople Urban VIII.

A number of great masterpieces are displayed in the Galleria Barberini. One is Raphael's Fornarina, the portrait of Raphael's beloved: Margherita Luti, the daughter of a baker in the Roman neighbourhood of Trastevere. A ribbon bearing Raphael's name is tied around the woman's left arm, as a symbol of belonging.

Caravaggio's painting of Judith Beheading Holofernes is extremely dramatic and realistic. The ferocity of the scene, which contrasts with Judith's elegant, distant, barely frowning beauty, is condensed in Holofernes' cry and spasm, with which Caravaggio masterfully captured the moment of death. The terrible beheading is represented in all its raw detail and realistic precision; every last detail is correct, from an anatomical and physiological point of view.

The Barberini Apartments, decorated in the Neoclassical style with paintings of nature and daily life.

✷ Borromini's Perspectives Gallery In Palazzo Spada: The Senses Can Be Deceiving

Because of the wide variety of subject-matters of its chosen works, Galleria Spada enables visitors to gain a particularly vivid idea of art collecting during the 17th and 18th centuries. Indeed, such subjects range from religion to mythology, from portraits to landscapes, from genre scenes to still life, and the works were drawn from several artistic schools.

Most of the works on display are from the collection of Bernardino Spada (1594-1661) and were later added to by his great-nephew, Cardinal Fabrizio Spada (1643-1717).

Crossing the courtyard of the Palazzo from the main entrance, on the left-hand side, through the central opening, visitors may see Borromini's renowned Perspectives Gallery (1559-1667). The surprise felt upon first glance is cause by the Gallery's illusory depth, of about 35 metres, which is much greater than the actual 8.82 metres: indeed, Borromini sought out to deceive the senses and confuse perception with an illusory effect. The columns, which appear to be 10 metres tall, actually vary in height between just over 5 metres and slightly under 3 metres. Even the statue at the end of the trompe l'oeil is as colossal as our mind is led to think, but is really only 60 centimetres tall. In this way, the Cardinal could display one of the most ingenious artifices of Baroque art, perhaps ascribing to it the moral significance of the deceptiveness of the senses and the illusiveness of earthly riches.

In the Third hall, one may admire the oil painting by Orazio Gentileschi (1563-1639) dating back to around 1610, on the subject of David with the Head of Goliath. The story of David and Goliath is told in the First Book of Samuel (17: 38-15). This canvas, however, represents a scene that is not recounted in the Bible. David is absorbed in meditation after having beheaded the giant. His expression is pensive, melancholy, almost as if he pities Goliath, who dared to challenge divine strength. This is the moment immediately before his entrance into Jerusalem holding the giant's head in

his hands; the city might be that painted behind him. A terse light shines over David's body, exalting its shapes and volumes. The painting was clearly inspired by Classical ideals of art and beauty.

The so-called Hall of the Popes, instead, hosts a painting of David with the Head of Goliath. The canvas, painted by Giovanni Domenic Cerrini, shows a very young David who turns humbly to the heavens, to indicate that he was able to perform his heroic act only with divine assistance.

✲ Galleria Borghese: Cardinal Scipione And The Sculptor Gian Lorenzo Bernini

Villa Borghese, with its artistic wealth and prestigious arboreal surroundings, is one of the most interesting historical Renaissance villas. It was the result of the important patronage activity undertaken in the early 1600s by Pope Paul V (1605-1621) and his renowned nephew, Cardinal Scipione Caffarelli Borghese (1576-1633).

Paul V's great attention to issues of water supply and fountains earned him the nickname of "Fountifex Maximus". He recovered the aqueduct built under Emperor Augustus along the Via Aurelia, to the north of Rome, and created the grandiose monumental fountain on the Janiculum Hill, known as *Acqua Paola* (Pauline Water).

The pontificate of Pope Paul VI was a period of consolidation and rigorous reform of Church power, and was marked by activities of evangelization on a global scale. The diplomatic relationships between the Holy See and all continents of the world, reaching as far as Japan, are celebrated to this day in the paintings of the Royal Hall of the Quirinale Palace, which portray the ambassadors of distant lands paying homage to Pope Paul V (painted in 1616-1617 by A. Tassi, G. Lanfranco and C. Saraceni).

Cardinal Scipione also commissioned one of Rome's 7 basilicas: San Sebastiano fuori le Mura (Saint Sebastian outside the Walls).

Scipione Borghese's project was to create a villa nestled in greenery, a place for leisure and rest, as well as for receiving and hosting important guests. In addition, he wished to house his antiques collection, the core of which was kept in the *Casino Nobile* at the centre of the complex.

The vast gardens were divided into three ample parts, each reflecting Baroque models. In particular, two formal trends are accosted to one another: in the first, the gardens are geometrically designed and shaped, while in the other, wild and unconstrained nature is exalted. The result is a natural landscape with heterogeneous elements. To complete the *Casino Nobile*, special gardens (called the "Secret Gardens") were created for the exclusive use of the Prince and his guests. The Secret Gardens were protected by walls hidden behind citrus trellises and embellished with flowerbeds full of rare species, such as the black tulip. Recently, after a significant reconstruction, the Secret Gardens have regained their original appearance with the reintroduction of the main arboreal and floral species that were grown during the 1600s.

A Bird Garden (*Uccelleria*) was built between 1617 and 1619, to house rare bird species. Another part of the garden was the *barco* or countryside, which, extending over 40 hectares, was the largest part of the villa. Here, the Prince would go hunting with his guests.

Of Cardinal Scipione's collection displayed on the first floor of the villa, we recall Titian's painting of Sacred and Profane Love (1514). The canvas depicts two female figures, one representing Sacred Love and the other Profane Love, both seated along the edges of a sarcophagus.

We understand that one of the women is a bride from a multitude of details: her hair is worn down and adorned with a myrtle crown, while a precious belt is tied around her waist (as a symbol of chastity). The container under her arm, trimmed with a metal edge, has been interpreted as a luxury version of the sewing basket that is part of the dowry of all good wives. The figure draped in red is Venus, who addresses the bride through the intermediation of Cupid. At the centre of the composition, a cherub mixes the water from the ancient sarcophagus, reminding the bride that she will

have to "mix" earthly love and sublime love. The sarcophagus is decorated with scenes of pitfalls and punishment: clearly, a warning to the bride.

On the first floor, viewers may admire a bust of Bernini, the story behind which is told by the sculptor's son Domenico, in the biography he wrote on his father. A crack runs across the forehead, unfortunately caused by Bernini's last stroke of the hammer; this made it impossible to present to the Cardinal. Next to it, a second bust of the Cardinal stands; Domenico narrates that his father created this unspoiled version in three days and three nights.

A statue sculpted by Bernini during his youth is linked to a story surrounding his debut. The marble block had to be paid for by the artist, and therefore by Bernini, then about 20 years old. Fortunately, all went well and there was no need to buy a second block.

In 1605, the Archconfraternity of the Papal Grooms of the *Palazzo Apostolico* asked Caravaggio to create a great painting for the new altar in Saint Peter's Basilica. Indeed, that year, the newly elected Pope Paul V Borghese galvanized the efforts to complete works on the Basilica.

Given the importance of the order, Bernini studied the composition with great care, as may be seen from the dense network of incisions made on the canvas to decide the figures' positions, as emerged in recent restoration works on the painting. The work, titled Madonna ad Child with St. Anne (*dei Palafrenieri*), was duly paid in April 1606 and immediately placed inside Saint Peter's Basilica. However, the painting was not well-received: the highly realistic, wrinkled features of St. Anne, the diminutive of the Christ, entirely naked, and the Virgin Mary, who looked like a peasant woman, sought to convey a sense of proximity between the divine and humanity. The painting was thus removed and purchased by Cardinal Scipione Borghese. In the contentious times of the Counter-Reformation (the Council of Trent had ended in 1563), Caravaggio, strictly adhering to Catholic orthodoxy, saw this painting as encapsulating the content of the papal bull on the Rosary, issued by Pope Pius V in 1571, to express the papal position in the debate between Catholics and Protestants on the

interpretation of the passage in the Book of Genesis (3:15) on the crushing of the serpent, symbol of the original sin. The theological significance of the painting focuses on the detail of the head of the diabolical snake, crushed by the foot of the Virgin Mary upon which presses that of the Child Jesus. In the bull, Pope Paul V clarified that the Virgin Mary had crushed the serpent with the help of her Son. This was a way to affirm the role of the Blessed Virgin in the salvation of humanity, against the Protestants' claims. St. Anne, who was the patron saint of the Confraternity, has a halo like the Virgin Mary. However, she does not partake in the action unfolding before her eyes. She is isolated, standing on the right, detached and meditative.

The last of the four sculpture groups commissioned by Cardinal Borghese for his suburban villa is the Apollo and Daphne, as if to compete with the grandiose ancient sculptures emerging during archeological excavations: the sculpture leaves viewers astonished, utterly fascinated – precisely as the commissioner and the artist desidred.

Before Bernini (1598-1680), no other sculptor had dared to create a statue representation of the story of Apollo and Daphne: it was far too long and complex to set in stone. In the *Metamorphoses* (Book I, verses 452-567), Ovid tells the story of how the god Apollo, struck by a golden arrow shot by Cupid, fell in love with the nymph Daphne, who had instead been pierced by a lead arrow, which made her flee "from the very thought of a lover". The young girl was sworn to chastity, but in the end the god prevailed. When Daphne heard Apollo about to close in on her from behind, she invoked a metamorphosis that would change her form. Bernini follows Ovid's famous description of the nymph's transformation into a laurel tree almost verbatim: Daphne's bust is ringed with bark, her hair turns into leaves, her arms into branches, her nimble feet into roots. In the meantime, Apollo's outstretched left hand can still feel, below the bark, the throbbing of human life.

At the base of the statue, Latin verses written by Maffeo Barberini are sculpted into a cartouche. The nobleman speaks of the bitter disillusionment that accompanies sensual pleasures; indeed, erudite visitors to the hall

would know that Daphne had always been seen as an allegory of chastity, of virtue fleeing pitfalls.

� On The Footsteps Of The Saints

Petros Eni: Peter Is Here

From the 4th century CE, Christians were finally accepted and were able to obtain a main church: Emperor Constantine built it for them on the tomb of the Apostle Peter, who had died in Rome during the time of Emperor Nero and had been buried in the old circus on the Vatican, in a necropolis not too far away from where he was martyred. However, in deciding the location of the basilica, Constantine, well aware of the importance of the memory of the Apostles (*memoria Apostolorum*), ensured a connection between the basilica and Peter's tomb, which was to be located under the altar. Today, Constantine's basilica may no longer be seen; the current Basilica was built on its ruins beginning in the 1500s. To this date, when we stroll around Bernini's baldachin, we may be certain that the remains of the Apostle Peter, who had been crucified upside down because he deemed himself unworthy of dying in the same way as Jesus Christ, are below our feet. The baldachin appears to be a faithful replica, albeit on a huge scale, of those which would be used during religious processions to protect the statues of saints from rain and sunshine. Bernini's structure, built to glorify Peter's tomb, is light and elegant. Although it is placed at the very heart of the scene and is illuminated by the light flooding in from the dome, it might almost be missed, because despite being 30 metres tall, it is positioned harmoniously at the centre of the Basilica, without blocking the view of visitors from roaming in all directions. The baldachin weighs 1,000 tonnes, but its supporting Solomonic bronze and gold columns are softened by their helical movement, which rises up towards the sky in an ascending line, wrapped with vines, around which the Barberini bees fly. The overall perception is, therefore, rather one of twigs trembling under an April breeze. The bees buzzing around the helix are not only a symbol

of the Barberini family, into which Pope Urban VIII was born; they are also the *apes argumentosae*, laborious bees, since ancient times dense with symbolism. Indeed, bees are the symbol of life, community, royalty, wisdom, laboriousness for the sake of the common good, zealousness, loyalty and prosperity.

The baldachin, which covers the altar and the tomb of Peter, is a development of the notion of a structure that preserves, protects and adorns, but is also an express reference to the prologue of the Gospel of John (1:14), which mentions the Word of God that became flesh and made His dwelling among men.

Bernini's genius lies in his idea to design a magnified processional baldachin, instead of a smaller structure: the overall impression is that of a procession of believers having temporarily stopped to pray at the tomb of the Apostle, waiting to resume the march.

We know that Peter, the first Apostle, the visibile leader of the Church, came to Rome in around 42 CE. Here, he established his seat and preached the Gospel of Christ.

Indeed, the risen Christ appeared to Peter on the Via Appia, as he was fleeing Rome as Nero's persecution of Christians intensified. The appearance has gone down in history as the astonished question that the apostle asked Jesus: *"Domine, quo vadis?"* (Lord, where are you going?") and the sad answer of the Christ: *"Venio iterum crucifigi"* (I come to be crucified again"). This exchange led Peter to decide to return to Rome, ready to face martyrdom. A small church still stands on the place where, according to tradition, the apparition took place, on the fork in the road between the Via Appia and the Via Ardeatina. The church dates back to the 9th century (but was renovated in the early 1600s) and is called the Church of *Domine Quo Vadis*.

During the persecution of Christians under the Emperor Nero, Peter was crucified on the Vatican Hill, asking to be nailed upside down to the cross as he deemed himself unworthy of dying in the same way as Jesus Christ.

On the site, where the early Christians immediately began to focus their veneration, the Emperor Constantine later built the first *Basilica Vaticana*.

For centuries, it was believed that the tomb on the Vatican Hill was that of Saint Peter. However, the scarce documentation and the literary sources of uncertain reliability caused significant doubts to arise over the years. Only more recently, from 1940 to 1952, upon initiative of Pope Pius XII, were meticulous excavations made in the Vatican's necropolis.

The surprising archeological finds contributed to confirming the authenticity of the tomb, thanks to the work of the archaeologist and epigraphist Margherita Guarducci (1902-1999), a collaborator of the Pontificial Roman Academy of Archaeology. It was Guarducci herself who was asked to resume these works in 1952, with astounding results.

Under the current papal altar of the Basilica of Saint Peter, a funerary shrine was found, standing against a wall which was built around the same time (150 CE, approximately). The wall was called "red" because of its colour, and is particularly important because of the mani graffitis carved onto it: Guarducci deciphered them all with her renowned talent. All of the inscriptions bear prayers to Peter, who is sometimes joined with the Christ and the Most Holy Virgin Mary, with an acclamation to "victory" in Greek: these are the well-wishes to a life "in Christ" and "in Peter", who is represented with his symbol, a key.

In the Vatican necropolis, on the tomb of the Valeri, Margherita Guarducci read *"Petrus, roga pro sanctis hominibus chrestianis ad corups tuum sepultis"* ("O Peter, pray for the holy Christian men who are buried near your body"). It is clearly a prayer for the Christians who had been buried near the remains of the Apostle, an indication that Peter had been buried there and was prayed to on that site. The other decisive graffiti dates back to 160 CE: in Greek, it states that *Petros enì*, which means "Peter is herein". This annotation, inscribed onto the Red Wall, indicates the precise location of the tomb of the Apostle Peter. On the basis of this graffiti, Guarducci stated that the Vatican Hill drew pilgrims already around 150 CE. With the tomb, the archeologist also discovered many of Peter's bones. To learn more

about this story, readers are directed to the fascinating book titled "The Tomb of Peter": "It was only in October 1962 that Professor Correnti could examine the bones found in the burial niche... The examination lasted until June 1963... In 1964, I became certain about the identification; in 1965, I first published the results obtained... The exceptional relics of Peter from a scientifically ascertained tomb, relics that had been declared to be authentic pursuant the most rigorous scientific examinations, demonstrate with absolute certainty that the Church of Rome is founded not metaphorically but actually on Peter, on the venerable remains of his body." Jesus's promise to Peter: "That thou are Peter, and on this rock I will build my Church" (Matthew 16:18) also became reality!

On the morning of Wednesday 26 June 1968, two days before the 1967/1968 Year of Faith called on the 19th centenary of the martyrdom of the Apostles Peter and Paul and during the audience in the Basilica Vaticana, Pope Paul VI announced that "New and very patient, very thorough investigations have been done for an outcome that We, comforted by the judgment of valiant and prudent competent persons, deem positive: the relics of Saint Peter have also been identified in a way which we consider convincing, and we praise those who have devoted very careful study and long and great energies to the matter".

Positioned at the centre of the Basilica, under Michelangelo's magnificent dome, which rises 132 metres into the sky in one of the most amazing architectural feats of all time, the papal altar represents the heart and pivot of the Basilica itself and of Christian Rome, as it stands directly above the burial place of Saint Peter. The Apostle Peter was the first pope, and his bronze statue draws millions of pilgrims from all around the world. The statue's right foot has been worn down by the kisses of the faithful.

The statue is attributed to Arnolfo di Cambio (1245-1302) and shows Peter seated in a gesture of blessing, while he holds keys, symbol of the power received from Jesus Christ to govern the Church. On the feast day of Saint Peter, which falls on 29 June every year, the statue is dressed with the sacred vestments and crowned with the Triregnum, the traditional papal liturgical headwear which Pope Paul VI (1963-1978) renounced

to emphasize the conception of papacy experienced not as power, but as a service to the Church. The words *"Tu es Petrus et super hanc petram aedificabo ecclesiam memam... Tibi dabo claves regni caelorum"* ("That thou are Peter, and on this rock I will build my Church...I will give you the keys of the kingdom of heaven", Matthew, 16:18-19), inscribed onto the golden internal band among the pendentives and the drum at the base of the great dome, testify to the will of the Saviour to provide visible continuity to his presence within the Christian community, through the figure of Peter and his successors.

Directly above Peter's tomb, the tangible sign of the Apostle's martyrdom and thus a "confession" of his faith, professed to the point of giving his life, stands the altar on which the popes usually celebrate solemn liturgies. Carved out of a block of white marble, it was consecrated by Pope Clement VII (1592-1605). Its direct connection to Peter's tomb emphasizes the continuity of all liturgical celebrations with the Apostle and, through him, with Christ.

One hundred and forty seven popes are buried in the Basilica of Saint Peter. The popes' funerary monuments dot the Basilica's naves or the Vatican grottos and tell not only the history of the papacy, but also of art.

The first woman to be buried in Saint Peter was Mathilde of Tuscany (1046-1115). Mathilde was a powerful feudal lady and ardent supporter of the Papacy in the fight for the investitures; at the very forefront of the times, during an age when women were considered inferior, she eventually came to dominate all Italic territories north of the Papal States. The "Great Countess" (*Gran Contessa*, or *magna comitissa*) Mathilde was certainly one of the most important and interesting characters of the Italian Middle Ages. She lived during an age of constant battles, entanglements and excommunications, yet demonstrated extraordinary strength, also enduring great suffering and humiliations, while displaying an innate aptitude for power.

Mathilde ordered the reintroduction of studies on the Digest of Justinian on civil law. The University of Bologna was established in 1088, when

Mathilde invited the scholar Wernerius to teach the ancient code and train those who would go on to manage the cities of Italy. In addition, over 100 cathedrals, churches and hospitals owe their construction or renovation to the patronage of Mathilde. Her faith in the Church of her times gained her the admiration and love of all her subjects. The funerary monument in her honour was sculpted by Bernini.

The Basilica of Saint Peter is the final resting place of other two women: Queen Christina of Sweden and Maria Clementina Sobieski, Queen of England.

One of the greatest masterpieces of the Vatican Museums is the Sistine Chapel. In 1504, following the appearance of a crack in the walls of the Chapel, Michelangelo was commissioned to design a new decoration of the ceiling, to replace the starry sky painted by Pier Matteo d'Amelia during the papacy of Sixtus IV. From the very beginning, Michelangelo underscored how difficult the work would be, given the massive undertaking that, as acknowledged by the sculptor, did not fall under his usual expertise.

The ceiling's architectural structure may be interpreted as a symbolic journey in which the fate of humanity is already written: from the primordial chaos to Redemption, an unavoidable premise to the events illustrated in the two cycles of frescoes dating back to the 1400s adorning the lower walls, in which parallels are constantly drawn between the episodes depicted in the mosaics and the life of Christ. From the lunettes and the respective panels, which show the Ancestors of Christ starting from Abraham, to the four corner panels which portray the heroic deeds of David, Judith, Moses and Esther, to the marble thrones upon which sit the prophets and the Sibyls, the importance of Divine intervention for the saving of mankind is always exalted. In the vault panels, next to monochromatic medallions depicting stories from the Bible, five scenes (the Creation, the Separation of Light from Darkness, the Creation of Eve, the Sacrifice of Noah and the Drunkenness of Noah) alternate with other four episodes of the Genesis. Beyond the ledge, in the broad azure vault, the decoration illustrates the mythical origins of the world (Creation of the Sun, Moon and Plants), which is populated by the Progenitors (the

Creation of Adam and the Temptation and Banishment), until the Great Flood. Michelangelo's fluid, transparent brushstrokes, imbued with light, emphasizes the plasticity of the monumental bodies. Although Pope Julius II lived to see the completion of the grandiose work once the Chapel was opened on 31 October 1512, the commitment to finalize the entire project, including the Last Judgment on the altar and entrance wall (which was supposed to receive the subject of the Fall of the Rebel Angels) would fall to Pope Clement VII.

The tremendous apocalyptic vision is centred upon the supreme gesture of Christ the Judge, who determines resurrection with the ascension of the chosen souls on the left and, on the right, the inexorable fall of the damned, in violent vortexes in which the angels themselves are caught up, either carrying the instruments of the Passion or pushing down sinners, as Minos looks on, a serpent coiled around him. Four hundred naked or seminaked figures soar upon God's call, in a space that is only spiritual. The fresco portrays the crucial moment of Judgment Day, in which the deceased will be called before Christ, to be judged. Some of them will be saved, while others will be plunged into hell. Christ Himself is the centre of the composition. His body is young and powerful, and the Virgin Mary stands next to Him. On the background, on the two opposite ends of the wall, the Blessed souls rise heavenwards in a dramatic ascent, disfigured by fear and by compassion for those who, at the opposite end of the fresco, are sentenced to eternal damnation because in that place beyond all space and time, they already know that divine grace can only be, precisely, divine. They know that it is not for them to judge, but only for Christ[56].

✻ Paul: Chained Ambassador To Rome (Ephesians 6: 20)

Paul came to Rome in 61 CE, for judgment by the Roman tribunal which would sentence him to death because he was a Christian. The sentence was executed in a place called the *palude Salvia*, or "Salvia swamp", on the outskirts of Rome. It would later be called *Tre Fontane*, or Three Fountains,

[56] Beltrame. *Op. cit.*, p. 228.

from the three founts of water which spouted out from the ground when the saint's head bounced three times on the ground; a church dedicated to Saint Paul stands here. His body was laid two miles away from the site of his execution, in the burial grounds that the Christian woman Lucina owned on the Via Ostiense. The Apostle Paul could be buried in a Roman necropolis even though he was Christian, because he was a Roman citizen. His tomb immediately became a site of veneration.

To enter the Basilica of Saint Paul outside the Walls, visitors must cross a square portico that measures 70 metres on each side, with 146 columns. It was designed by Luigi Paoletti in 1868 and built between 1890 and 1928 by Guglielmo Calderini (1837-1916). The works maintained the basic Paleo-Christian architectural structure. At the centre, between flowerbeds and palm trees, the statue of a strict Saint Paul sits, made by Giuseppe Obici (1807-1878). In one hand, the Apostle holds a sword, symbol of his martyrdom, and in the other, a book, to emphasize his activity of announcing the Word of God, written and proclaimed. Saint Paul is also depicted on the façade of the basilica, to the left of Christ; to the right of the Savior, instead, is Saint Peter.

Under the façade, a broad vestibule opens. It allows entry into the basilica through its three majestic doors.

In the liturgy of the Church, doors have both functional and symbolic meanings. In the Gospels, Christ Himself identifies with a door, in a clear reference to life after death. For this reason, the doors of churches were and are often decorated with bas-reliefs, some by great artists, and are beautiful not only in aesthetic terms, but also in terms of functionality to Christian symbolism.

Of the three doors of the basilica which open out onto the vestibule, the oldest and the most important is that on the right, if the visitor faces the façade. It was placed to close the Holy Door.

The creator of that which is considered one of the most beautiful doors in the world is Theodorus of Constantinople. Some inscriptions also record the name of his founder, Staurachius, the date (1071) and the

identity of the commissioner, Pantaleon, a consul from Amalfi, who is also portrayed in one of the 54 panels composing the door's decoration. Again in Constantinople, the consul commissioned other two important bronze doors: that of the *Duomo* of Amalfi and that of the Sanctuary to the Archangel Michael at Monte Sant'Angelo, in Puglia (southern Italy). It is also known that his father had another famous door made, for the abbey of Montecassino.

The silver panels narrate, starting from the top, the life of Christ, starting with the Nativity throughout the Pentecost, followed by images of the prophets and the Apostles. The door of the main entrance to the basilica, also in bronze, is 7.48 metres tall and 3.35 metres wide, and was created between 1929 and 1931 by the sculptor Antonio Maraini (1886-1963). The Benedictine abbot Ildefonso Schuster, renowned liturgist and later Archbishop of Milan, laid out its iconographic design. On the door, a large cross decorated with vines is carved, with the Apostles and the symbols of the four Evangelists. To the sides of the cross, five panels per side tell episodes linked to Peter's and Paul's presence in Rome, ending with an illustration of the two saints' martyrdom. The two images of Christ, made of repoussé silver, at the centre of the two doors, are very interesting. In the image on the right, Jesus names Peter head of the Church; in that on the left, He converts Saint Paul on the way to Damascus.

The sense of monumental spaciousness within one of the largest basilicas in the world is a result both of the symmetrical layout of the 80 granite columns and of the mirroring effect of the floor.

Under the windows of the central and side naves, mosaic portraits of the popes from Saint Peter to our days are nestled. Other than their certain value for the purposes of iconographic research, these portraits also respond to historical and theological needs, first and foremost that of establishing the dates of the various pontificates, and then the necessity to emphasize the line of apostolic succession, from Peter until the most recent living pope, who thus gains legitimacy as the successor of the first Apostle and, therefore, most authoritative representative of Christ for the Church.

Under the altar lies the holiest place of the entire Basilica – the tomb of the Apostle Paul. An opening made during the latest renovation works undertaken on the Basilica affords visitors a partial view of Paul's sarcophagus. On the marble burial tablet, the words *Paulo apostolo mart...* are inscribed. Near Paul's tomb lie also the remains of Timoty, who together with Titus were the Apostle's favourite disciples. In three letters, two to Timothy and one to Titus, which the Church preserves among the remains revealed by the Sacred Scriptures, Paul shows great love for the disciples, encourages them to live coherently with the message of Christ and gives advice to each, which resonates and is enlightening for Christians to our days, after two thousand years.

In Rome, it is also possible to visit the house where Saint Peter used to live: today, this is the Church of San Paolo alla Regola. Little is known for certain about this church: while we are aware that it was built well before the year 1000, the date of its initial consecration is unknown, possibly because it dates too far back in time.

The author of the Acts of the Apostles, usually highly attentive to Paul's deeds, concludes his work with a "summary" in which he describes the Apostle's life in Rome. Here, he was detained under a regime of *custodia militaris*, according to which he nevertheless remained free to preach: "He spent the whole of the two years in his own rented lodging. He welcomed all who came to visit him, proclaiming the kingdom of God and teaching the truth about the Lord Jesus Christ with complete fearlessness and without any hindrance from anyone" (Acts, 28: 30-31)

Paul came to Rome twice. First when he was brought to the city by the centurion Julius after he made a plea to the Emperor before the Governor of Judea, Festus[57]. Paul's plea sought to demonstrate, to his fellow citizens, his faith in the risen Christ. This first detention lasted two years (from 61 to 63 CE) and ended with his liberation, as Paul himself wrote in his letters.

[57] Cf. Acts, 27: 1.

As written by Saint Luke[58], Saint Paul was a tentmaker by trade. As many other trades, this was probably plied by the Jews on the banks of the river Tiber, where leather tanning was also done. Indeed, another tradition dating back to the 2nd century CE, supported by important archeological findings, indicates another dwelling place, the first of the people's apostle in Rome: this was a house rented out in spring of the year 61 CE on the banks of the river, on the Tiber's great bend just before the *Isola Tiberina*.

Therefore, it was possibly in this home that Saint Paul wrote his letters during his first jail term in Rome (to the Colossians, to Philemon, to the Ephesians and to the Philippians), near which the Acts of the Apostles were probably written by Saint Luke: the two saints were indeed inseparable.

In 1552, on this same site, from which the memory of the Apostle had not yet vanished for good, the corporation or university (as it was then called) of the *Vaccinari*, the leather tanners and dyers was founded, under Pope Julius III. In light of the location and of the influence of the Pauline tradition, during religious functions the *Vaccinari* would wear white robes with an image of Saint Paul sewn onto the shoulders[59].

The Apostle came to Rome as a prisoner: in Jerusalem, when accused of contempt of the Mosaic law, Paul asserted his status as a *cives romanus*, a Roman citizen, which automatically allowed for him to be trialled in Rome. In the capital of the Empire, he had been given a residence permit and the possibility to "stay in lodgings of his own with the soldier who guarded him" (Acts, 28: 23). This detention system, named *custodia militaris*, which allowed prisoners the chance to choose their own residence, required them to be guarded by a soldier, who would accompany them whenever they left the lodgings, chained by the wrist. In any case, Paul was free enough to pursue his apostolate and spend most of this semi-detention teaching and preaching (Acts, 28: 23).

Paul's lodgings were found to be in the underground of the Church of San Paolo alla Regola. In that area, today's Regola neighbourhood, leather

[58] Acts, 28: 3.
[59] Fanucci. *Trattato di tutte le opere pie di Roma*. Rome. 1601. P. 407.

artisans (mostly Jews) had settled. There, Paul practiced his trade as a tentmaker, which led him to meet people and spread the Good Word in the capital of the Empire.

Once the two years under *custodia militaris* were up in the home on the banks of the Tiber, Paul was released, because the trial was most likely not held, possibly because those who had accused him in Jerusalem decided against undertaking the long, expensive journey towards Rome. Finally free, Paul visited his friends, first his beloved Aquila and Prisca, whom he had met at Corinth.

The couple, who had risked their lives to save Paul at Corinth, had gone to live on the Aventine Hill once they returned to Rome. Their home, which was a true domestic church, hosted many of Jesus's first followers in the city. Other than Paul, Peter too had been welcomed to the house of Aquila and Prisca. As for Prisca, Paul had also baptized her, using – according to tradition – the baptismal fount which may still be seen today in the church of Saint Prisca on the Aventine Hill.

Paul could also count on the help of other families to support and host him in Rome: that of Marcellus and Pudente (a relative of Prisca's), who belonged to the senatorial class. The excavations conducted under the church of Saint Pudentiana, named after one of Pudente's daughters, brought to light a refined household that held strong from the late republican era to beyond Nero's age.

Paul too, during this brief period of freedom, was able to fulfil his wish to meet the members of the beloved community of Rome in better conditions, before resuming his travels, which would lead him first to Spain, the westernmost territory of the Empire, and then to Ephesus, in Macedonia and Troad.

The current façade of the church of San Paolo alla Regola dates back to 1721. The chapel of the main altar closes with a semicircular apse and is adorned by three large frescoes, painted by Luigi Garzi. The central fresco illustrates the conversion of Saint Paul; the left one, the Apostle's preachings; and the right fresco depicts his martyrdom, all beneath a choir

in walnut wood, created in the 1700s. On 14 May 1860, Pope Pius IX declared the altar to be a privileged altar from which it would be possible to acquire indulgence from sins in perpetuity.

Four steps down, visitors descend into the chapel dedicated to Saint Paul, in line with the ancient tradition according to which the Apostle lived here and spent here the two years of his Roman imprisonment, which he mentions in the last chapter of the Acts of the Apostles (28: 33).

Paul's second journey to Rome, however, probably took place only during the later stages of the persecution of Christianity, and shortly before he was martyred in the capital of the Empire in June 66 or 67 CE.

Being thus able to enjoy greater freedom, although retaining the need to hide from persecutors and his fellow countrymen, Paul took up lodgings in several places around Rome. One of these was the home of Saint Luke the Evangelist on what used to be the Via Lata (today, Via del Corso). The archeological remains of this house may be accessed from the church of Santa Maria in via Lata.

In the crypt of this church, visitors may view the ruins of a Roman *domus* dating back to the 1st century BCE – the house of Saint Luke the Evangelist. Paul lived here during the years of house arrest pending the trial; Saint Peter would also live here for a short while.

Pietro da Cortona created an underground path to foster pilgrimage to the sites considered to be the lodgings of Peter, Paul and Luke. That moment would, upon the impulse of Pope Alexander VII, mark the consolidation of the cult of ancient Christian tradition in Rome.

Via Lata, the ancient name of Via del Corso, was not very far from the Mamertine Prison, at the foot of the Capitol Hill, where the prisoners who had received the capital punishment were detained.

According to the historian Ammianus Marcellinus, starting from the 6th century, the Prison was venerated as the site of the detention of Peter and Paul, who according to the traditional timeline, were martyred on the same

day, on 29 June of the year 67 CE, the day which the Church today has devoted to the celebration of the two apostles.

It is certain that in 66-67 CE, Paul returned to Rome and was detained, but this time under the *custodia publica* regime, a tough form of detention reserved to the worst criminals, inside a Roman praetorium. He may have been arrested in Troad, all of a sudden, as may be deduced from his request to Timothy to retrieve his travel cape, scrolls and books.

Paul is by now weak. He cannot hide his disappointment at having been left alone during the first hearing; only the ever-faithful Luke remained by his side, while his enemies regained strength. It is the same abandonment that Christ had experienced at the hands of His disciples.

"The Lord will rescue me from every evil attack and will bring me safely to his heavenly kingdom. To him be glory for ever and ever. Amen." Paul has reached the end of his apostolic journey, because he is now in Rome. He is well aware that he will have to endure other tests, tests which he is however certain of passing by holding on to his faith in Christ, his hope and strength.

�907 St Agnes: The Courage Of Testimony

According to her *passio* (story of the death of martyr), the son of the Roman prefect, who had seen her as she was walking home from school, had sought to marry her. She was no older than 12 or 13, the age at which Romen women were allowed to become engaged. Her suitor begged her to marry him, offering her – if she accepted – houses, riches and luxury, as well as the chance to become a member of the prefect's family. It was not possible, answered Agnes; she was already betrothed to someone much more important that he was, and who loved her more[60].

[60] Visser. *Geometria d'amore*. Book Sprint edizioni. 2015. p. 140.

At the time, women who did not wish to get married could either become vestal virgins, and cerry out sacrifices to the Roman gods, or live in a brothel. Agnes chose the brothel. The prefect's son went to the brothel with a group of friends to outrage her modesty. However, as soon as he stretched out his hand to touch her, he fell to the ground. But Agnes prayed to God; the prefect's son not only recovered, but also proclaimed that he was converting to Christianity.

History tells us that, since Agnes refused to change her mind, it was decided to burn her alive; however, the flames "parted", flew away and burned the crowd that had gathered to watch her execution[61]. Ultimately, her throat was slit. During this terrible test, the brave little twelve-year-old resolutely held her ground[62].

The last chapter of Agnes's *passio* narrates that her parents, after having buried her sister Emerentiana (to whom a church not far from that of Saint Agnes outside the Walls is dedicated), spent entire nights keeping vigil at their daughter's tomb. Once, at midnight, they saw a great light and a multitude of virgins appeared to them, all dressed in golden robes, walking in a long procession. Among these virgins was their daughter. The parents were wholly astounded. Agnes asked the procession to pause for a while. She spoke with her parents and told them not to be sad for her, but rather to share her joy because she now lived, together with all those marvelous creatures, in complete intimacy with He who she had loved on earth, more than any other thing.

This scene is represented in the ample mosaic unfurling along the central nave of the 6th-century Basilica of Saint Apollinare Nuovo in Ravenna, in the northern Emilia-Romagna region of Italy. This splendid mosaic depicts a row of women, whose halos are all covered in gold. Each woman, under her cape, wears a bejeweled robe; each woman carries a crown, symbolizing their martyrdom. Agnes stands out among them because a white lamb is at her feet. Indeed, the lamb is the symbol of Saint Agnes.

[61] Visser. *Op. cit.* p. 352.
[62] Pseduo-Ambrogio. *Gesta Sanctae Agnetis.*

The lamb (in Latin, *agnus*) is something of a visual play on words on the girl's name. in Greek (indeed, her name derives from Greek), *hagne* means "full of religious fear"[63].

The Church of Saint Agnese in Agone stands on the site where, according to tradition, the saint was held naked in the stocks; miraculously, her hair grew to cover her. The current structure of the church was initiated by Girolamo and Carlo Rainaldi in 1652, under Pope Innocent X, and completed by Francesco Borromini (1653-1657). The dome, supported by 8 columns of *Cottanello* marble, was decorated with frescoes (Glory of Paradise) by Ciro Ferri in 1869; the pendentives (Cardinal Virtues) by Baciccia (1665). Saint Agnes is buried at the Basilica of Sant'Agnese fuori le mura (St Agnes outside the Walls).

The catacombs dating back to before the martyr's deposition, which took place under the persecution executed by the Emperor Valerian or Diocletian, have three storeys.

✠ Santa Maria Della Vittoria And Bernini's Ecstasy Of Saint Theresa

Sculpted by Bernini in 1646, in this church, architecture, paintings and sculpture all contribute to a highly dramatic impact. At the centre of the scene is Saint Theresa of Avila, pierced by her love for God, as in the vision recounted by the saint herself: "Our Lord was pleased that I should have at times a vision of this kind: I saw an angel close by me, on my left side, in bodily form. [...] He was not large, but small of stature, and most beautiful – his face burning, as if he were one of the highest angels, who seem to be all of fire [...] I saw in his hand a long spear of gold, and at the iron's point there seemed to be a little fire. He appeared to me to be thrusting it at times into my heart and to pierce my very entrails; when he drew it out, he seemed to draw them out also, and to leave me all on fire with a great love of God. The pain was so great, that it made me moan; and yet so surpassing was the sweetness of this excessive

[63] Visser. *Op. cit.* p. 361.

pain, that I could not wish to be rid of it." A ray of light from a skillfully hidden opening in the roof illuminates the Carmelite saint as she slides unconscious from her soft bed of clouds, before the gazes of the Cornaro family (including the commissioner) who peek out from the side choirs. The curved pediment disguises the window that Bernini designed such that the ecstatic scene would be flooded with diffuse light[64]. The chapel, one of Bernini's masterpieces, is one of the most amazing representations of Roman Baroque.

✠ Saints Praxedes And Pudentiana: Piety Beyond Cruelty

Daughters of the Roman senator Pudente (who Saint Paul mentions in his Second Letter to Timothy, 4: 21) and sisters of Timothy, Praxedes and Pudentiana were martyred in Rome in the 2nd century. One church is dedicated to each of them. In Rome, during the time of Antoninus Pius and of the persecutions, the two sisters took pains to bury the martyrs in the cemetery of Priscilla (on the Via Salaria) and to collect their blood, at once sacred and innocent. Praxedes would pour it into the well of her father's home – the *domus* on the Esquiline Hill which would later become the Basilica bearing her name – and defended to her death. In the Basilica of Saint Praxedes, 2,500 martyrs are buried; Pope Pascal I had ordered the transfer of their remains.

✠ Saint Cecilia: A Girl From Trastevere

This story begins in the 2nd century CE, during Marcus Aurelius's rule, on the day that the converted patrician Cecilia was martyred. Cecilia faced her martyrdom with courage, singing hymns to God – this led to her becoming the patron saint of musicians, as well as of the Roman *Conservatorio*, or music school, named after her. Moreover, Cecilia's death

[64] Touring club italiano. *Roma*. Trieste. 1994. p. 295.

was particularly bloody, as the young girl did not die after the three days during which she was confined to the *calidarium* (hot baths) of her *domus*; nor after the executioner tried to cut off her head. Indeed, the man struck three blows; the iron pierced her body, but her head remained in its place. When the executioner, out of exhaustion, finally stopped dealing blows, Cecilia took her last breath and almost immediately, became one of the city's most beloved martyrs[65].

In an attempt to honour a devotion that, from the very beginning, was very intense, one century later, the *Titulus Ceciliae* was built on the house that may have belonged to the young martyr's family; upon this, the Paleo-Christian church ordered by Pope Gregory the Great in the 6th century would be built. The basilica's spiritual and other heritage is immensely wealthy; innumerable artists throughout the ages left small and big masterpieces today inside the church. The statue of Saint Cecilia sculpted in 1599 by Stefano Maderno, whose fingers indicate three and one, represents the mystery of the Trinity. The story behind Maderno's sculpture is one of great tenderness, compassion and empathy. Even in the moment of martyrdom, divine love is to be perceived as a pacifying energy, and the beholder should understand it as a force that is capable of providing respite even at the moment of greatest suffering.

The Eternal City bears innumerable traces of the saints who have lived here. At the Church of Santa Maria sopra Minerva, where Saint Catherine of Siena (1347-1380), the patron saint of Italy, is buried, she undertook intense charitable activities and wrote many letters in the name of God to both religious and civilian authorities, seeking to promote peace. Saint Catherine managed to convince Pope Gregory XI (1370-1378) to return to Rome from Avignon.

In Piazza Farnese, there are the rooms transformed into frescoed chapels where Saint Brigid, patron saint of Europe, lived and died. In the Church of the Ara Coeli, Saint Helena is buried; mother of the Emperor Constantine, in Jerusalem she found the remains of the Holy Cross and is the patron saint of archeologists.

[65] Beltrame. *Op. cit.* p. 255.

As for the more recent saints, in Piazza del Gesù stands the *Casa Professa* of the Jesuit order, built between 1599 and 1623 as the headquarters of the Society of Jesus. Visitors may view the rooms of Saint Ignatius of Loyola. The Spanish monk, founder of the Jesuit Order, moved to Rome to the headquarters of the Society of Jesus, where he died in 1556. The rooms were frequented by Ignatius, and are are accessed through a corridor with splendid frescoes by Father Andrea Pozzo (painted in 1695) with the illusory perspectives typical of the Roman Baroque. In the Basilica del Sacro Cuore, on Via Marsala, one may see the rooms where Saint John Bosco lived and performed miracles, as well as the youth centres that are found in all Salesian initiatives around the world. As for Saint Camillo de Lellis, two churches in Rome are dedicated to the patron saint of the ill, who after a dissolute youth, devoted his life to serving the sick and bringing about reforms of the health system.

The promenade along the Palatine Hill, the Hill of the Emperors, is particularly suggestive, with its view of the Forum, as well as the walkway under the dome of Saint Peter's Basilica.

Venice: The Serenissima And Its Maritime Glory

I N THE 1ST century BCE, the name "Venetia" indicated an administrative region of the Roman Empire encompassing the modern-day Veneto, Istria, Friuli and Trentino regions.

In Venice, official religious, civilian, political and military celebrations took place constantly throughout the year. For the occasions, public buildings would be lavishly decorated; flags and textiles from the East would be displayed on the façades of houses and on the loggias of palaces; porticoes and arches of triumph would be erected in the city squares, or *campi*. Everyone took fervent part in these magnificent celebrations, which would be honoured with the presence of Venice's ruler, the *Doge*, as well as processions and parades, which became a true ritual of the city's political and spiritual life.

The Great Council of Venice (*Maggior Consiglio*) chose the *Capitano generale da mar* (General Captain of the Seas). This was the highest position of the Venetian Navy, and appointment to the post was made official by the ceremony of the handing over of the staff of command, which would take place in the Basilica of San Marco. Exiting the Basilica after the ceremony, the captain would lead a procession until the Piazzetta, surrounded by a guard of honour firing celebratory blank shots. The grandiose ceremony was attended by the *Doge* and the *Signoria* of Venice,

the supreme governing body of the city; it also provided an opportunity to celebrate Venice's maritime might[66].

The ceremony of the Corpus Domini, which took place in early June, was incomparable for the richness of the costumes, the profusion of flowers, the myriad candles, and the extraordinary variety of colours. The Republic's civil and religious authorities paraded with pomp and circumstance in Piazza San Marco, as may be seen in the paintings dating back to the 15th century.

The Republic's life was also marked by lavish receptions held in honour of ambassadors and foreign monarchs visiting Venice.

The Venetian Carnival would start on 26 December and culminate on Fat Thursday. Under the costumes and the typical masks, social inequities would be temporarily erased, whereas official celebrations, in which the hierarchies were strictly codified, emphasized them. The Venetians streamed out onto the *campi*, Piazza San Marco and the courtyards, which became stages where people could posture, dance, sing and take part in games. The Carnival began with great balls held on the largest *campi* of the city, followed by parties for weeks, until Fat Tuesday. On midnight, the bells of the church of San Francesco della Vigna sounded the death knell to mark the beginning of Lent[67].

Some costumes drew inspiration from the characters of the Italian *Commedia dell'arte* form of theatre (such as Harlequin): plays would be held on all *campi* of the city.

During the Fat Thursday celebrations, the *Volo dell'angelo*, or Flight of the Angel, was held: an acrobat flies down a rope tied between the Bell Tower and the Doge's Palace to bring a bouquet of flowers to the *Doge*[68]. This ceremony is re-enacted also today.

[66] Touring club italiano. *Venezia*. 1992, p. 49.
[67] Touring club italiano. *Venezia*. 1992, p. 53.
[68] Touring club italiano. *Venezia*. 1992, p. 50.

Today, costumes based on 1700s dress and traditional characters may be found alongside the most unusual outfits. As in the past, balls and plays are held and visitors may watch ancient games. The traditionally made Carnival masks are beautiful gifts to buy as souvenirs.

A discussion of Venice cannot fail to mention the regattas: in front of the Ca' Foscari Palace, the regattas' arrival point, a platform was constructed where the city authorities would award coloured flags to the first four participants, including a red flag for the winner.

A special regatta was open only to women: the first one was held in 1493 in honour of Beatrice d'Este, the wife of the Duke of Milan, Ludovico il Moro. Fifty girls took part in this race, which is traditionally held even today.

The *Vogalonga* is a veritable nautical festival. On the day of the Ascension, hundreds of boats of all kinds gather in the starting place, Saint Mark's Basin. The participants must sail 30 kilometres: after reaching the island of Burano through the canal of Cannaregio and the Grand Canal, they come back to the starting point. This test of stamina also requires great rowing skills; before the race, the participants train for months in the *voga veneziana*, or Venetian rowing tradition, in the city's canals.

The Historical Regatta takes place on the first Sunday of September. Large vessels filled with characters in historical dress parade down the Grand Canal, alongside fleets of smaller boats. Afterwards, four races are held between characteristic Venetian boats. Several different types of gondolas can take part.

The very shape of gondolas was studied to perform well in regattas. The gondola for the women's regatta has a light, pointed hull. The *desdotona*, instead, is an 18-row boat for opening water parades. A special type of gondola was built for funerals. Finally, the *bissona veneziana* is an 8-row boat whose bow is adorned with a lion, the symbol of Venice.

In the past, gondolas became so excessively decorated that in 1663, the Republic decreed that they should all be simple and painted only black.

When the Venetian aristocracy began to travel on private gondolas manned by a permanent gondolier, this figure, which assisted to all his clients' trips, even the most illicit ones, became a sort of confidant. Today, the gondola, the symbol of Venice, is essentially a tourist attraction. There are about 400 today that slip through the canals of the city.

Once richly dressed, gondoliers today wear a "uniform" of a black suit and a straw hat with a red or blue ribbon.

Gondolas are true masterpieces of naval construction. Their hulls extend lengthwise (11 metres long and less than 1.5 metres sideways): only half of their bows touch the water, such that the floating surface is reduced to the minimum possible. The gondolier stands astern, facing the bow.

The nearby islands of Burano and Murano are also renowned; the former for its production of lace and the latter for its exquisite glass. Burano is 9 kilometres away from Venice, to which it is connected with a ferry. Its other particularity is that its houses are all of similar height and are all painted with lively colours. These are small rustic buildings, at most two storeys tall, with similar façades into which simple square windows are carved. According to tradition, the task of painting the houses in deep red, dazzling yellow, intense blue was once entrusted to the island's women, while the men worked at sea. The radiant colours served to allow the fishermen to recognize their homes from afar, as they sailed back towards land.

In Burano, the lacemaking and embroidery traditions date back to the 15th century, when the women would work on these crafts in convents, in charitable institutions and in the private homes of Venice and the surrounding islands. However, when the *punto in aria* stitch was invented in the mid-16th century, needle lace developed and soon became a specialty of the island[69].

Murano has a long glassmaking tradition. The production of glass in Venice began between the 10th and the 11th centuries. The glassmakers soon formed a guild and later, in 1291, their activities were moved to Murano.

[69] Touring club italiano. *Venezia*. 1992, p. 371.

From the mid-14th century, the artisans of Murano began to export their wares, becoming famous for their glass pearls and mirrors, which started to be sold in bulk starting from the 15th century. From the 1450s, production would expand from exclusively practical-use merchandise to become a true art form. Many types of glass were created: enameled glass, goldstone glass (streaked with gold), glass imitating gemstones such as chalcedony, multicoloured *millefiori* glass, and many more.

Given the rising importance of the glass industry, the artisans enjoyed several privileges but were also restrained by strict political control. Glassmakers were prohibited from emigrating, upon penalty of confiscating all their possessions. However, it is known that starting from the 16th century, some glassmakers did manage to settle in Northern Europe, where they launched prosperous businesses.

In the 17th and 18th centuries, glassmakers focused their attention to the forms of their products. Venetian mirrors and chandeliers became immensely successful throughout Europe.

The *Museo del vetro* (Glass Museum) is unique in Italy and is housed in one of the biggest palaces of the lagoon, the Palazzo Giustinian. Here, visitors may trace the evolution of tastes and techniques, as they admire the glassmakers' tools and learn about the various stages of the process.

✦ Palazzo Ducale – The Duge's Palace

Residence of the *Doge*, seat of the government and of the administration, the Doge's Palace was also home to an armory, courtrooms and prison cells. Each governing body (*Maggior Consiglio*, Senate and the Council of Ten, or *Consiglio dei Dieci*) was to be endowed with a seat worthy of its authority and of that of the Republic. The Doge's Palace also features the largest hall in Europe. The seaward façade of the Palace was oil-shined, such that it could be admired from the sea in all its brilliant glory.

Power was not concentrated in any of the administrative bodies. None of the authorities enjoying decision-making power could escape the check of another. The rapid changeovers established for the positions – except for that of the *Doge* and of the 9 Procurators of Saint Mark, or treasurers – made it hard for individuals or factions to gather power. In addition, this system enabled opposition voices to be heard without great difficulties, as all members participated in decision making and in the elections to the positions. The complexity of the administrative system, moreover, ensured any excess of personal ambition to be short-lived. In this way, the city's government was as stable was it was effective until 1797.

On the ceiling of the Sala dei Tre Capi (Room of the Three Heads) is a fresco by Tintoretto whose subject is drawn from the New Testament: an old man, seen from behind, gazes towards a small figure in the distance – a representation of the parable of the Prodigal Son.

A famous detainee of the *Piombi*, or Leads, prisons – because they were made of lead panels – was Giacomo Casanova (Venice, 1725 – Duchcov, Czech Republic, 1798, where he is buried). Casanova narrated the story of his rambunctious escape from the prisons in his work titled "The Story of My Escape from the Prisons of the Republic of Venice, Otherwise Known as the Leads", which was translated into several languages and republished 48 times until 1958. When Casanova wrote it, he was already in Dux (the old name of Duchcov), ready to wind down his adventurous life, among books and in the relative tranquility of the Waldstein Castle. He therefore had no need to spare any regard for the people or institutions of the Republic of Venice, and confessed his youthful excesses and justified the Tribunal's work. He was imprisoned *per cole di religione*, that is, for atheism; for associating with the Freemasons; for attitudes inspired by the Enlightenment; and for dangerous conduct, at least as the institutions of the Republic considered it. However, at the time of his escape, he did not yet know the sentence that would be imposed upon him, nor could he know that the authorities had intended to release him after less than a year.

"I admit to being proud that I was [the author of the escape], but I can assure the reader that my vanity does not stem from the fact that I succeeded, good

luck played a huge role in that, but from the fact that I judged the plan workable and that I had the courage to undertake it"[70]. "The Lord has disciplined me severely, But He has not given me over to death." (David, Psalm 118)[71].

With the help of Divine Providence[72], once he managed to reach the main entrance to the Doge's Palace, he considered his work to be complete and that the rest was up to God[73]. After several attempts, he managed to escape on All Saints Day.

"September 12th, 1774, Mr Monti, consul of the Republic of Venice in Trieste, gave me a note from the State Inquisitors, in which they ordered me to present myself in one month's time to the *circonspect* Marcantonio Businello, their secretary, to know their will. […] Instead of waiting a month, I got myself to Venice within twenty-four hours and I presented myself to secretary Businello […] As soon as I told him my name, he kissed me, bade me sit close to him, told me that I was free and that my grace was recompense for my account of the story of Venice's government from Amelot of the Houssaye, that I had published in three volumes four years previously. He told me that I had done the wrong thing in fleeing, as if I had just had a little patience, I would have been set free. I responded that I believed that I had been condemned to stay there for my whole life. He rejoined that I should not imagine that, because 'for little fault, little pain'.

"At that I interrupted him with some emotion and I begged him graciously to communicate my fault, because I had never been able to guess it. The wise *circospetto* responded then only by looking at me seriously, while putting the index finger of his right had on his lips […] I asked no more. I demonstrated to the Secretary the feelings of respect with which I was truly touched and I assured him that in days to come the Tribunal would never have cause to repent themselves of the utter grace of which they had found me worthy.

[70] Casanova. *The Story of my Escape from the Prisons of the Republic of Venice otherwise known as The Leads*. A.K. Lawson (transl.). CreateSpace Independent Publishing Platform. 2014. P. 74.

[71] Casanova. *Op. cit.* p. 197.

[72] Casanova. *Op. cit.* p. 185.

[73] Casanova. *Op. cit.* p. 207 ff.

"After this step I dressed myself and I began to rejoice in the pleasure of showing myself to the whole great city, where I immediately became the news of the day. I was welcomed one by one at the homes of the three benevolent inquisitors, who received me graciously and invited me to dinner, each in turn, to hear from my own lips the beautiful story of my flight, which I narrated to them without disguising anything [...]

"Those to whom I made long visits and to whom I knew to attach myself were the three patricians who had taken an interest in me, who had worked hard in order to obtain my grace, and who had obtained it. [...]

"Everybody waited to see me provided with a job agreeable to my capacity and necessary for my subsistence; but all the world was mistaken, except me. Whatever the establishment, anything I could have obtained through the favour of a Tribunal whose influence had no limits would have had the air of recompense, and it would have been too much. It was supposed of me that I must have all the talents required by a man who wants to be self-sufficient, and this opinion did not displease me; but all the pains that I gave myself over the space of nine years were in vain. Either I am not made for Venice, I said to myself, or Venice is not made for me, or perhaps both.

"In this ambiguous state, a strong disagreement came to my aid and made up my mind. I decided to leave my country as one leave a house which is pleasant, but where one has to suffer an inconvenient nasty neighbor, who one can not persuade to move. I am now at Dux, where, in order to be agreeable with all my neighbours, it suffices only that I do not reason with them, and nothing is easier than that."[74]

In Venice, a gondola ride to view the majestic palaces and exquisite bridges dotting the city as well as suggestive, picturesque scenes of daily life, affords tourists a particularly evocative experience. Other suggestive sights are the Bell Tower of Piazza San Marco, from which to view the entire city, and the Secret Itineraries tour of the Doge's Palace, which was the true core of the Republic of Venice.

[74] Casanova. *Op. cit.* p. 263 ff.

Epilogue

*A*T THE END of this voyage, the journey has only just begun…
I thus leave readers with the emotions stirred in me by these lovely
Italian cities. In writing, I focused on the places I know most about;
however, everyone should undertake their own personal itinerary, because
traveling through Italian cities provides not only a chance to explore an
immensely wealthy culture and history, but also to embark on a spiritual
journey – a journey of the soul. All visitors will certainly identify with
the feelings, sensations, and experiences of those who have lived in and
left their mark on these places, even centuries ago, perhaps also drawing
inspiration to face the challenges posed by our world today. "If "Beauty
will save the world", then such a trip would certainly be worthwhile. I wish
buon viaggio to all!

It is Sunday. I have just attended Mass and am strolling around Villa
Borghese. The sun is shining, children are playing. My phone rings and I
pick up, but work is still far on the horizon. I cannot help but think that
it is a truly magnificent day…

\mathcal{B}ibliography

Associazione culturale Santa Maria di Castello. *Genova. Santa Maria di Castello.* Sagep Editori. 2014.

Averame. *101 cose da fare a Genova almeno una volta nella vita.* Newton Compton editori. 2011.

Beltrame. *La storia di Roma in 100 monumenti e opere d'arte.* Newton Compton editori. Roma 2015.

Càlzia. *Guida segreta alle cose da fare gratis (o quasi) a Genova.* 2012.

Casanova. *The Story of my Escape from the Prisons of the Republic of Venice otherwise known as The Leads.* A.K. Lawson (transl.). CreateSpace Independent Publishing Platform. 2014.

Coltellacci. *I segreti tecnologici degli antichi romani.* Newton Compton editori. Roma, 2016

Crispino. *Le chiese di Firenze.* Giunti. 1999.

Delpino. *"Operazione sunrise". L'ultimo miracolo. La vera storia della baronessa che nell'aprile 1945 salvò Portofino dai nazisti.* Edizioni Tigullina. 2012.

Dolcino. *I Misteri di Genova.* Nuova editrice genovese. 2014.

Fanucci. *Trattato di tutte le opere pie di Roma,* Rome. 1601.

Fiorenza. *Nel giardino inglese della Reggia di Caserta*. Angelo Pontecorboli editore. Florence. 2016.

Gallico. *Guida ai Fori e al Colosseo*. ATS Italia editrice 2000 Roma.

Goethe. *Observations on Leonardo da Vinci's Celebrated Picture of the Last Supper*, G.H. Noehden (transl.), Booth & Rivington: London, 1821. Marani. *Il cenacolo di Leonardo*. Skira. 2009.

Orselli-Roffo. *Genova segreta*. Ligurpress. Genoa. 2010.

Poliziano. *Letters. Volume I, Books I-IV.* S. Butler (transl., ed.). The I Tatti Renaissance Library, Harvard University Press: Cambridge, MA, USA. 2006.

Roffo-Donato. *Guida insolita ai misteri, ai segreti, alle leggende e alle curiosità di Genova*. Newton Compton editori. 2015.

Savonarola. *Treatise on the Government of Florence*. In *Selected Writings of Girolamo Savonarola: Religion and Politics, 1490-1498*, A. Borelli and M. Pastore Passaro (transls, eds). Yale University Press: New Haven, CT, USA.

Visser. *Geometria d'amore*. Book Sprint edizioni. 2015.

Printed in the United States
By Bookmasters